The Craft Beer Sticker Book

The Craft Beer Sticker Book
Published by Soi Books
ISBN: 978-1-7397509-4-7

The Craft Beer Sticker Book
Published by Soi Books
ISBN: 978-1-7397509-4-7

The Craft Beer Sticker Book
Published by Soi Books
ISBN: 978-1-7397509-4-7

The Craft Beer Sticker Book
Published by Soi Books
ISBN: 978-1-7397509-4-7

The Craft Beer Sticker Book
Publish
ISBN: 9

Proost
Saúde
Skål
Prost
Fenékig
Sláinte
Kanpai
Salud
Cin Cin
Terviseks
Kippis

Hello! Welcome to the first ever craft beer sticker book.

There is no question that creativity and art in the world of craft beer are at an all time high. As big fans of design, illustration and, of course, beer, putting this book together and getting to know a lot of great breweries has been a privilege.

Drop in at your local off-license or liquor store, wander down any supermarket beer aisle, or search out your beers online, and you will surely notice that craft beer labels have become a form of art in their own right. Crafting the label has become as important as brewing the beer. Strong words; but breweries have to have an eye-catching label design to stand out from the crowd and instantly attract the customer's attention.

This need to be noticed lies at the root of the profusion of creative artwork you will discover in this book. There is artwork not only from America and Europe, but from breweries across the world who have embraced craft beer. In fact, it is the global nature of the artwork that first drew us to this niche field. (That and the beer!)

In this first craft beer sticker book, we highlight 38 craft breweries from all over the world, exploring their diverse label designs and beers along with the stories behind them. And in classic Stickerbomb fashion we share these designs with you as stickers for you to decorate, illustrate and brighten up your life. Cheers!

ALTES TRAMDEPOT
BERN, SWITZERLAND

We are a small craft beer brewery in the middle of Bern, the capital of Switzerland. Our brewery is a pub brewery, which belongs to the restaurant Altes Tramdepot and was founded in 1998. The beer has always been produced in huge copper kettles in the middle of the restaurant. All beers are unfiltered, natural and produced without chemical additives - a natural product! Brewing takes place four to six times a week, resulting in more than 3,000 hectolitres of beer per year.

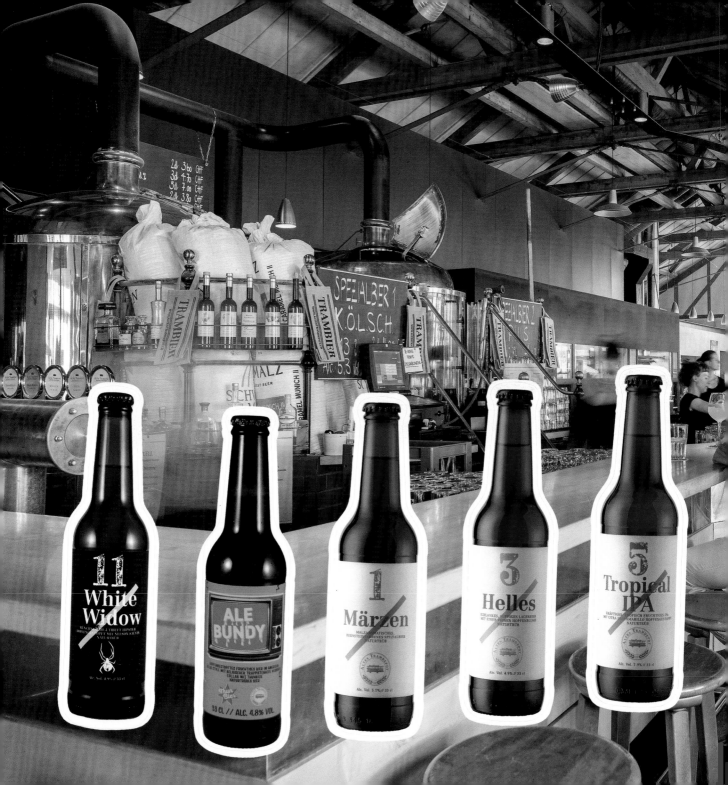

AMUNDSEN BREWERY
OSLO, NORWAY

Amundsen Bryggeri is an Oslo-based brewery focused on producing craft beers of the highest quality for the non-conformists out there. Our motto is 'Created by Craftsmen' as we see ourselves as modern day craftsmen, hand-crafting and producing ales, lagers and sours. At Amundsen we believe in innovation and creativity, and strive to produce world class beers from only the finest ingredients we can lay our hands on. Quality, consistency and passion to improve are what drives us on from day to day. Our artwork is by Peter-John de Villiers, based in Stadlandet, Norway.

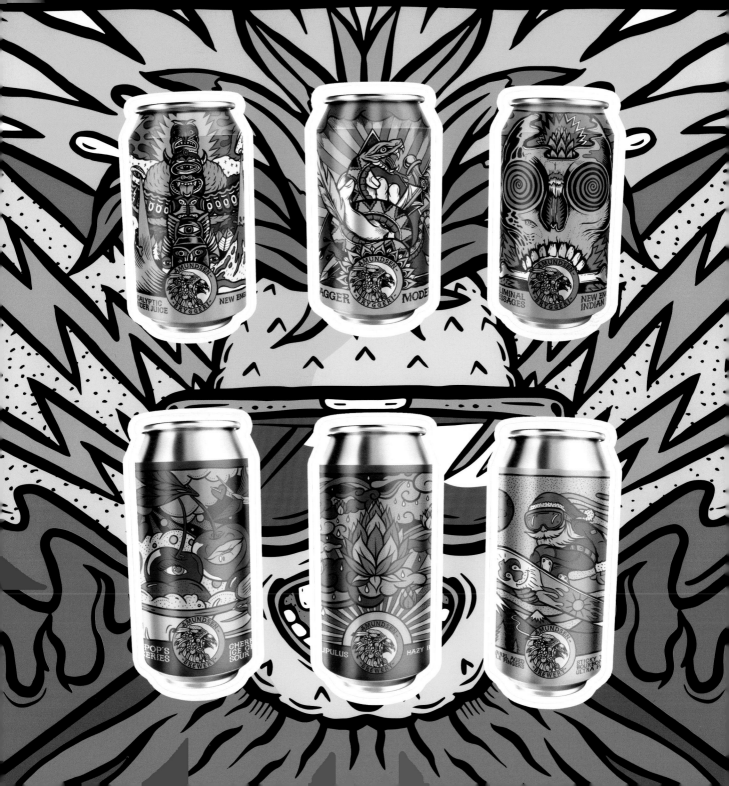

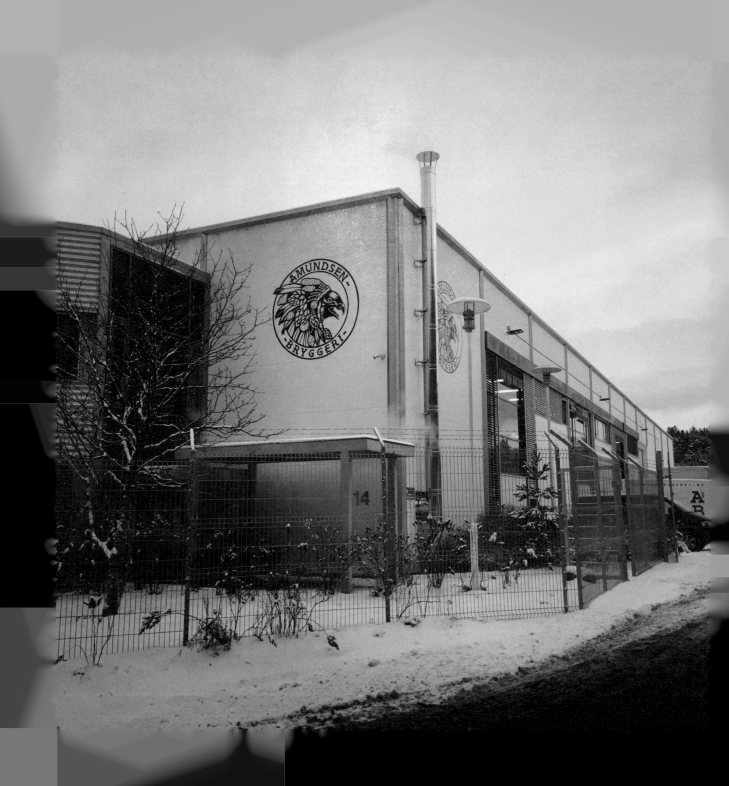

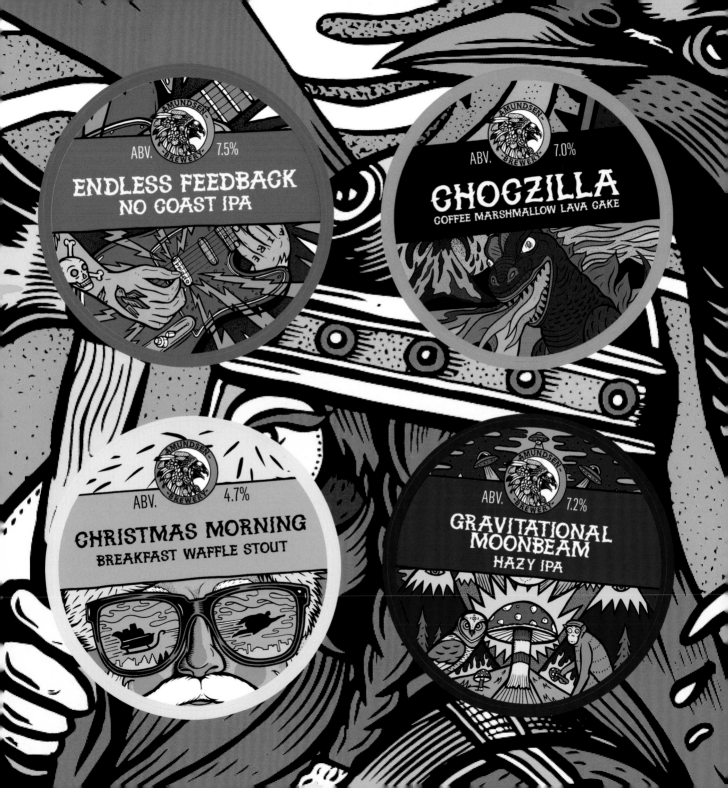

ABV. 7.5%
ENDLESS FEEDBACK
NO COAST IPA

ABV. 7.0%
CHOCZILLA
COFFEE MARSHMALLOW LAVA CAKE

ABV. 4.7%
CHRISTMAS MORNING
BREAKFAST WAFFLE STOUT

ABV. 7.2%
GRAVITATIONAL
MOONBEAM
HAZY IPA

BASQUELAND BREWING
GIPUZKOA, SPAIN

Basqueland makes true-to-style craft beers utilising the best ingredients and techniques, from the heart of the Basque Country, for the whole of Europe. We are dedicated to making beer on a par with the Basque culinary experience and are proud to be global ambassadors for the Basque community throughout Europe and the world. As a flagbearer for craft beer, we accept the responsibility to lead by example as artisans and as good citizens.

ASK FOR BASQUE

www.basquebeer.com

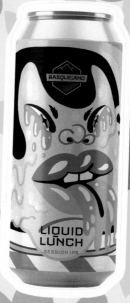

BASQUELAND

DRY H
MOSA
MOTU
CITRA
MOSA

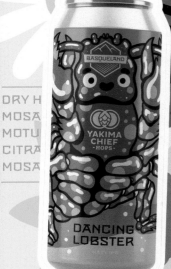

DANCING LOBSTER

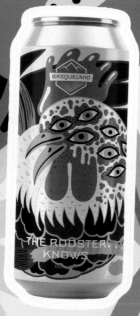

THE ROOSTER... KNOWS

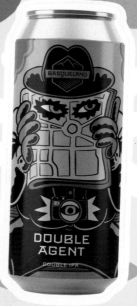

DOUBLE AGENT

DOUBLE IPA

LIQUID LUNCH

SESSION IPA

Garagardoa · Bière
Beer · Cerveza · Öl · Bier

440 ML | 14.9 FL OZ
Alc. 5,2 % vol.

SUMMERTIME

SESSION IPA

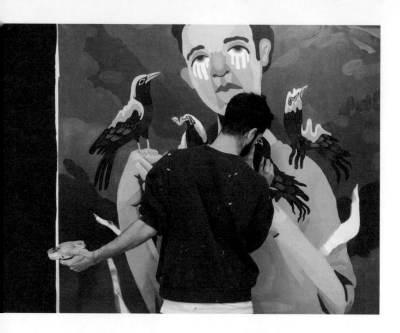

Interview with artist Marcos Navarro

Please introduce yourself and how long you have been working with Basqueland?
I'm an illustrator and painter from Barcelona, now based in the Basque Country. I grew up influenced by subculture and underground movements in Barcelona, but nowadays in the Basque Country my work is constantly related to wildlife and nature. I started working with Basqueland in 2019. I was sharing a studio with Allan Daastrup, a Danish typographer. Allan did all Basqueland's branding, including their typeface. Every time they came to the studio I had a new painting to show, and this is how we started talking about collaborating on some beer art.

What's the most fun part of designing a beer label?
Designing for a craft beer label! I mean, they are really open minded, and they like to explore boundaries as brewers, as well as with the product in the market, so they give me 100% freedom to do my characters, crazy compositions or just follow my style research.

Why do you think beer cans have become such a prominent medium to showcase artwork?
I think it's due to a mix of these things. Brewery founders are very open minded and normally they start with small teams, so it's easier to work with them. Also their customers crave new beers, and consume fresh stuff. There is a huge diversity among craft breweries so you can also find a great variety of graphic styles: typography, photography, illustration, pattern - everything is so different. This helps so much in creating cool stuff!

Could you explain the inspiration or messages behind some of your can artwork featured in this book?
Coastal Eddie was inspired by Eddie Aikau, a Hawaiian surfing legend. He is a hero and inspired many generations of riders worldwide. Easter egg: 'Eddie would go', a popular saying between surfers when waves are too big. Pintto is the brewery pet and the name of the dog comes from a folkloric song in the Basque Country, 'Pintto Pintto'. Double Agent, a Double IPA has an illustration 100% inspired by Inspector Gadget.

Do you like beer? If so, what's your top recommended Basqueland beer?
I love beer but when I started working with them I didn't know much about craft beers. To be honest, every beer style has a moment. My everyday beer is Aupa. My beer for hot days, Santa Clara. Sharing beers with friends I start with Hazy IPA or West Coast, and continue with DIPA. One remarkable beer for me is: Coastal Eddie - Black IPA. Enjoy!

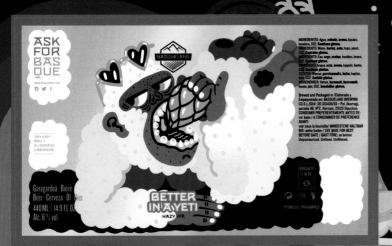

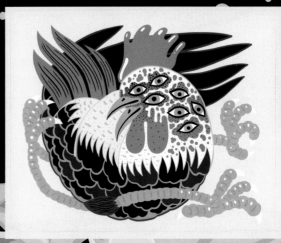

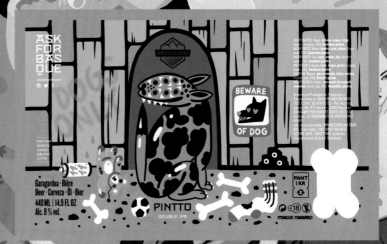

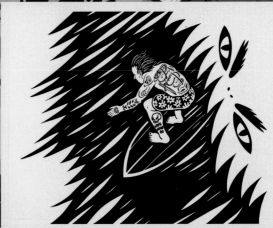

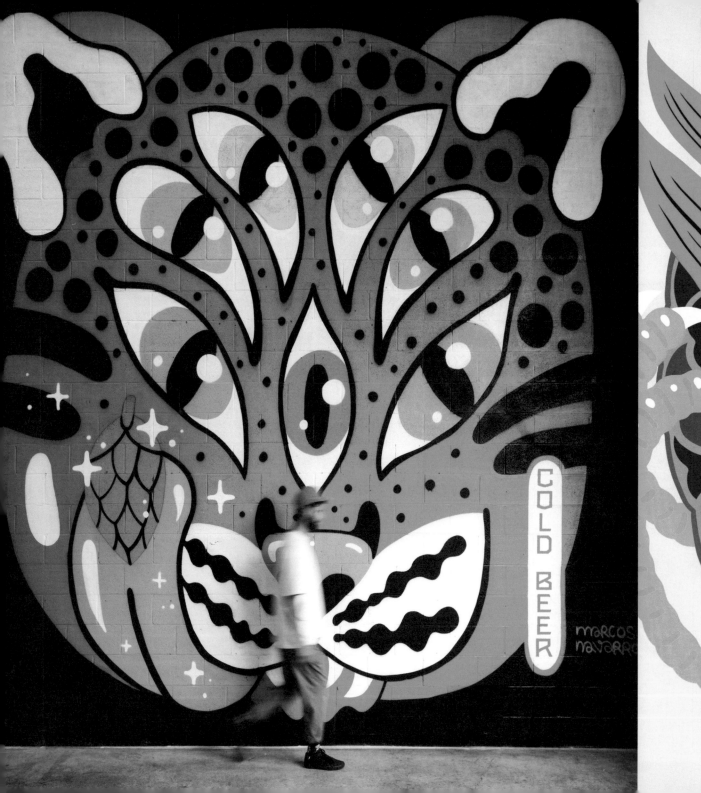

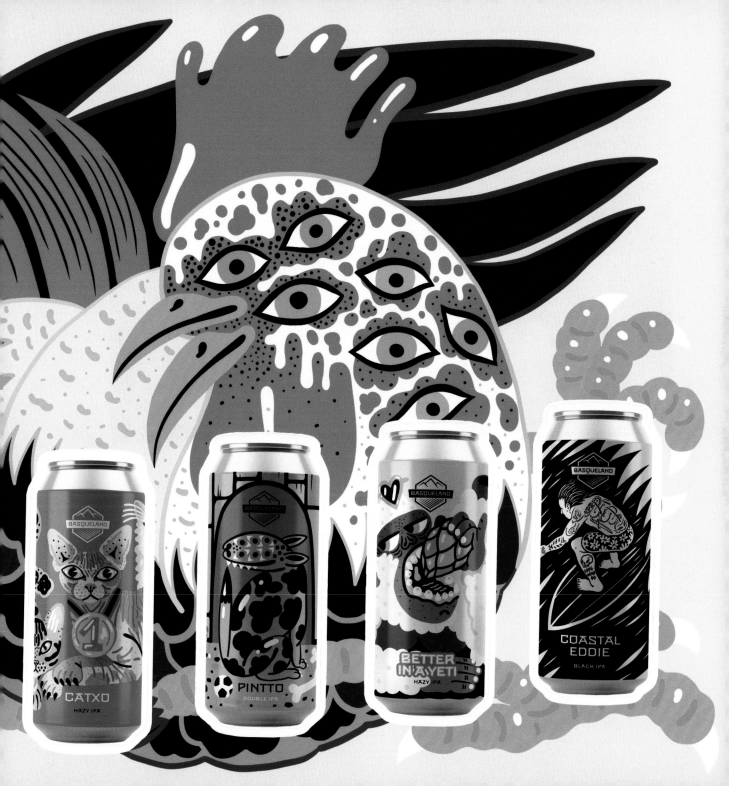

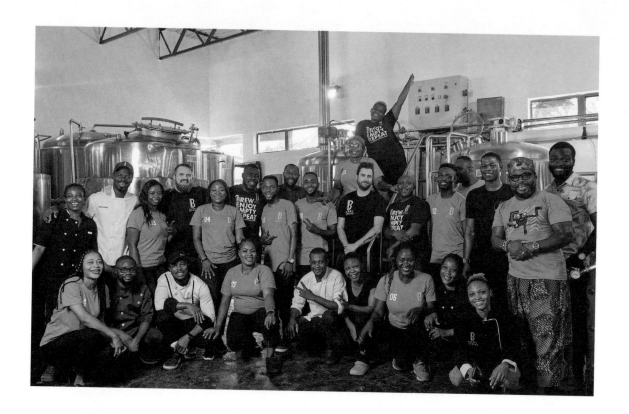

BATURE BREWERY
LAGOS, NIGERIA

Inspired by the Naija hustle and a passion for creating unique beers using local ingredients, we are the first craft brewery in Nigeria and pioneers of craft beer in West Africa. We are on a mission to make the best beers in Nigeria, leading the way in flavour, innovation and style. Revolutionising the African beer industry through disruptive marketing and technology, customer engagement and the art of the hustle.

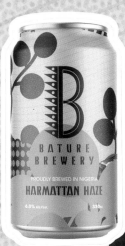

HARMATTAN HAZE
6.0% Alc/Vol. 330ml

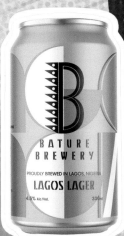

BATURE
BREWERY

PROUDLY BREWED IN LAGOS, NIGERIA

LAGOS LAGER
4.8% Alc/Vol. 330ml

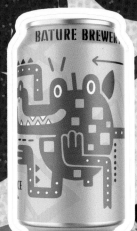

BATURE BREWERY

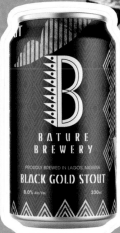

BATURE
BREWERY

PROUDLY BREWED IN LAGOS, NIGERIA

BLACK GOLD STOUT
8.0% Alc/Vol. 330ml

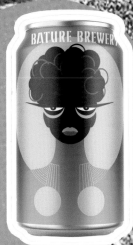

BATURE BREWERY

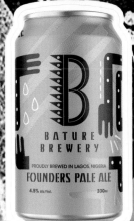

BATURE
BREWERY

PROUDLY BREWED IN LAGOS, NIGERIA

FOUNDERS PALE ALE
4.5% Alc/Vol. 330ml

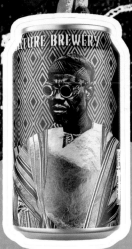

BATURE BREWERY

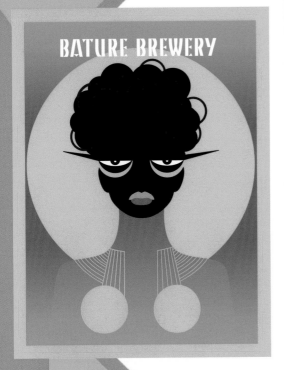

BATURE BREWERY

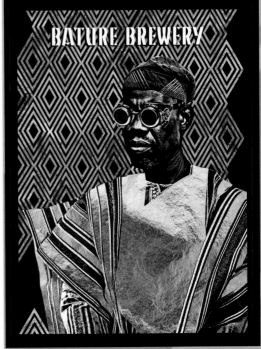

BATURE BREWERY

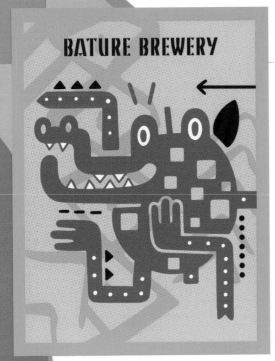

BATURE BREWERY

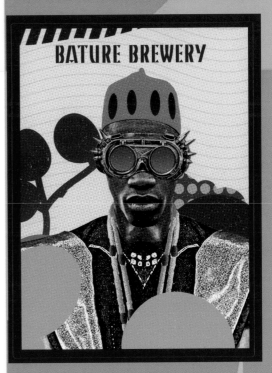

BATURE BREWERY

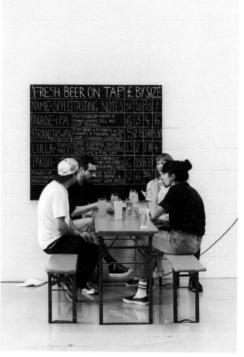

BEAK BREWERY
LEWES, UK

Beak began life as a nomadic project run by food and drink writer Daniel Tapper, who spent several years honing his recipes with friends at some of the UK's greatest breweries, including North Brew Co, Burning Sky and Northern Monk. The project has since laid roots in the East Sussex town of Lewes where it also runs an award-winning taproom and street-food canteen. Though best known for its hop-forward IPAs, the brewery has established a small but growing mixed-fermentation project, showcasing seasonal ingredients sourced from the surrounding South Downs National Park.

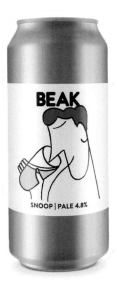

SNOOP | PALE 4.8%

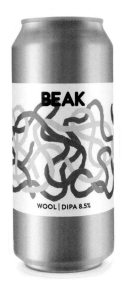

WOOL | DIPA 8.5%

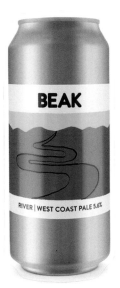

RIVER | WEST COAST PALE 5.6%

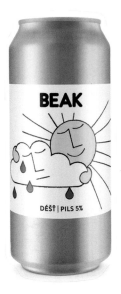

DÉŠŤ | PILS 5%

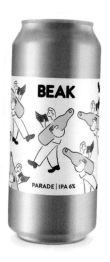

PARADE | IPA 6%

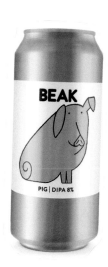

PIG | DIPA 8%

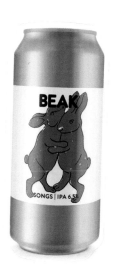

SONGS | IPA 6.5%

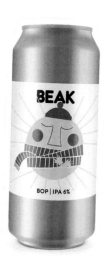

BOP | IPA 6%

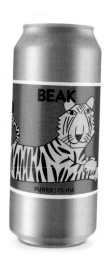

PURRR | 7% IPA

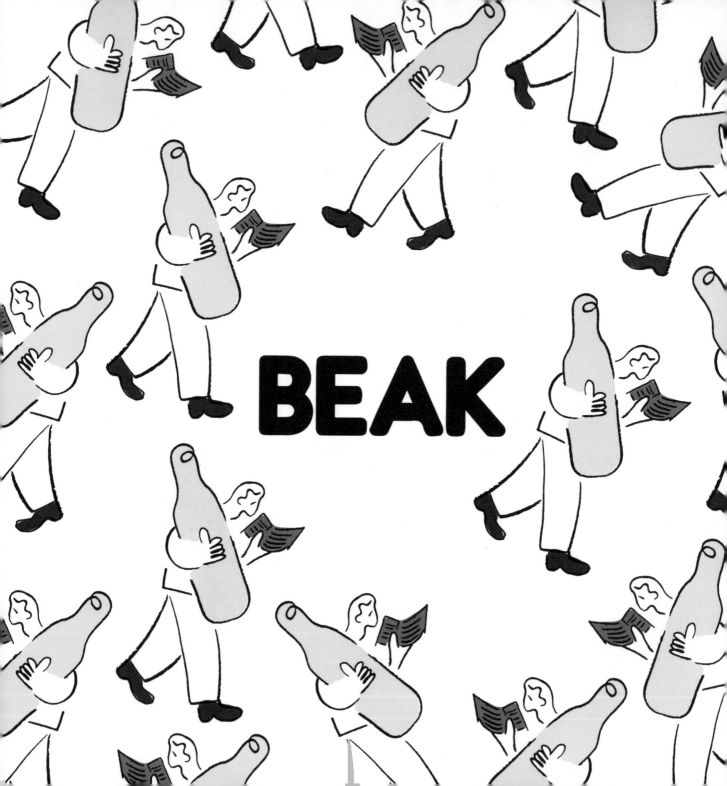

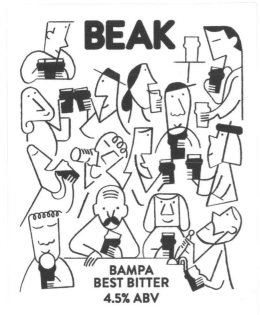

BEAK

BAMPA
BEST BITTER
4.5% ABV

BLACK KITE BREWERY
WONG CHUK HANG, HONG KONG

Black Kite Brewery is inspired by the majestic birds of prey that glide through the skies over Hong Kong. Soaring between mountains and high-rises, these magnificent creatures epitomise that rush of freedom we all crave during long days in the city.

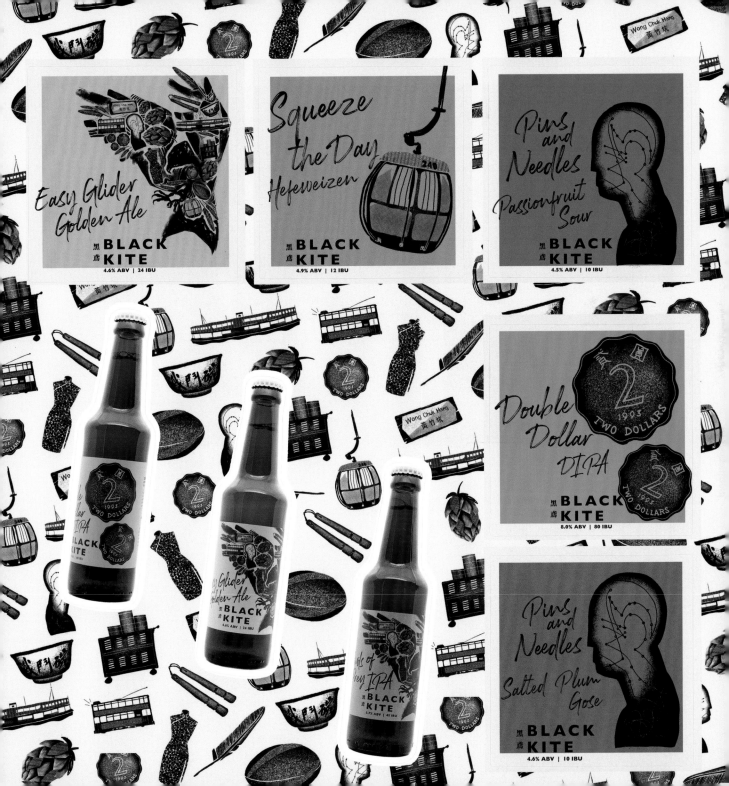

BLITZ BREWING CO
ALKMAAR, NETHERLANDS

Established in 2019, Blitz Brewing Co is building its reputation by constantly investing in quality and flavour. This mantra of 'taste first, everything else second', together with a powerful commitment to delivering the best beers we can to our customers, has underpinned the brewery's success. Our belief that beer should unify is the cornerstone of our brand. There is nothing we love more than sharing a craft beer with people who love to drink them and having a good time. But in the end our goal is simple: to brew the best goddamn beer you'll ever taste.

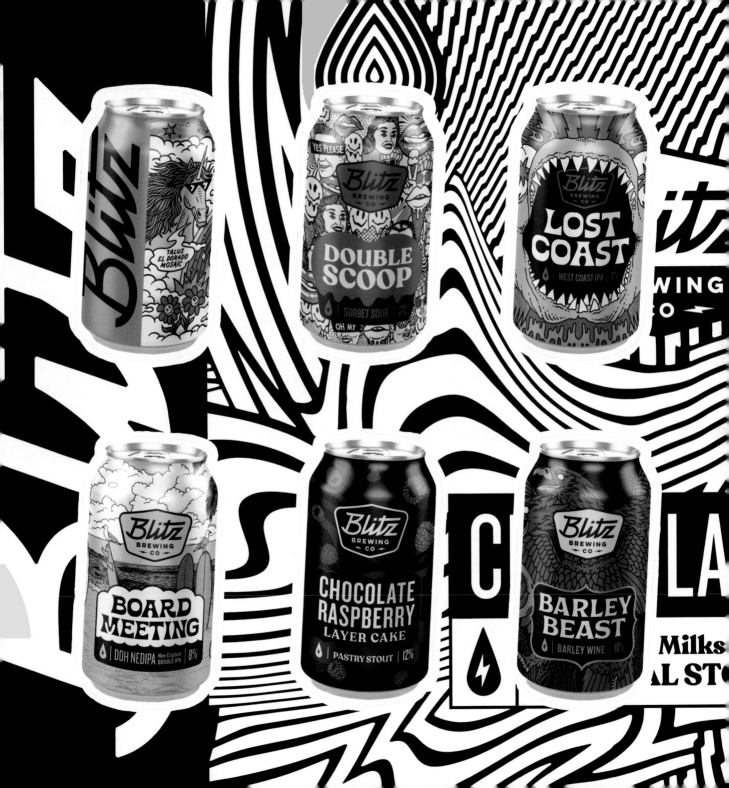

BOARD MEETING

△ | ⚡ | DDH NEDIPA New England DOUBLE IPA | 8%

GALAXY · AZACCA · MOSAIC

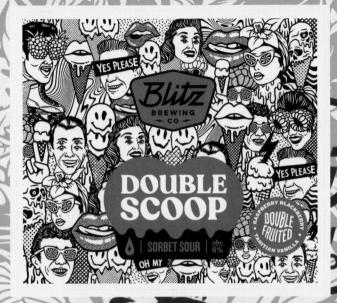

DOUBLE SCOOP

SORBET SOUR | abv 6%

DOUBLE FRUITED · RASPBERRY BLACKBERRY · TAHITIAN VANILLA

YES PLEASE · OH MY

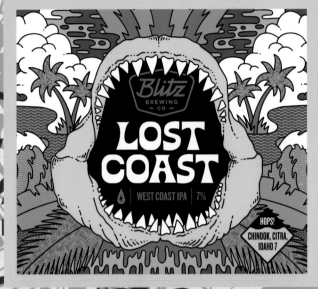

LOST COAST

WEST COAST IPA | 7%

HOPS! CHINOOK, CITRA, IDAHO 7

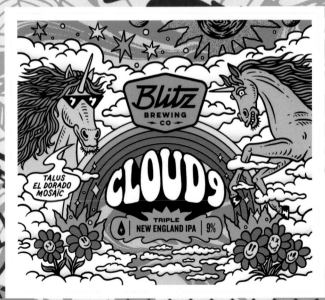

CLOUD 9

TRIPLE NEW ENGLAND IPA | 9%

TALUS EL DORADO MOSAIC

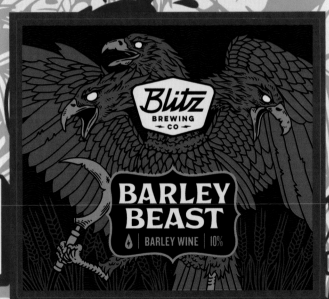

BARLEY BEAST

BARLEY WINE | 10%

New England Double IPA

BRASSERIE DE LA SENNE
BRUSSELS, BELGIUM

Brasserie de la Senne is at the origins of the 'new wave' of craft beer in Brussels. We have been working, among other things, at encouraging the taste for well-hopped beers before they became trendy. Next to hoppy ales, we produce barrel-aged mixed-fermented beers, as well as beers refermented with a local Brettanomyces yeast. We aim at brewing beers of character that are well-balanced, with a requirement for quality and consistency, absence of compromise, and a totally natural production, as well as an extremely sharp selection of raw materials in a direct relationship with the producer.

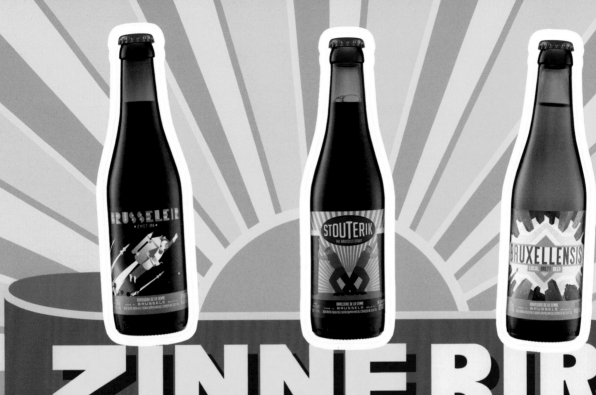

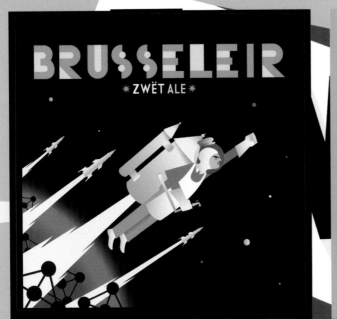

BRUSSELEIR
✱ ZWËT ALE ✱

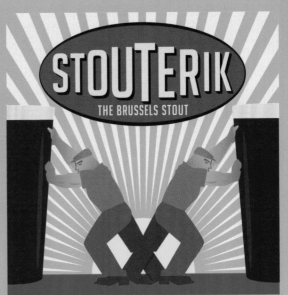

STOUTERIK
THE BRUSSELS STOUT

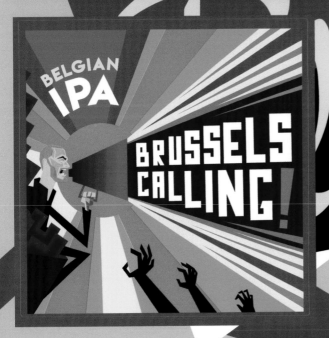

BELGIAN
IPA

BRUSSELS
CALLING!

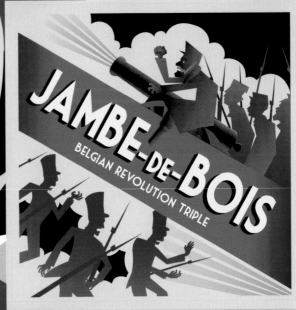

JAMBE-DE-BOIS
BELGIAN REVOLUTION TRIPLE

BREWCCOLY
AKITA, JAPAN

Brewccoly is a local brewery that started brewing in Akita city in the autumn of 2018. It is still rare in Japan for a brewery to suddenly appear in the middle of an ordinary cityscape. We aim to be that 'local beer shop in town' that blends in with the city. Brewccoly is a coined word that combines the words 'brewery' and 'broccoli'. Why broccoli? Because it's my favourite food!

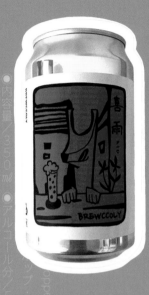
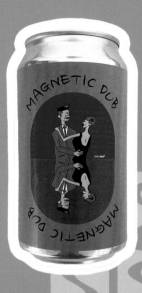

●お酒は20歳になってから。

●製造者／筒井智成 秋田市中通3-4-27パークハイツ中通1F

●内容量／350㎖ ●アルコール分／5.0% ●

○ップ・アイリッシ

pped Saison

mood

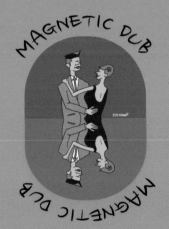

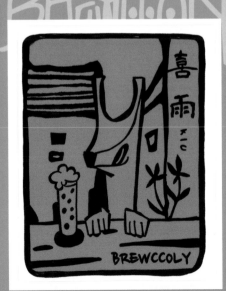

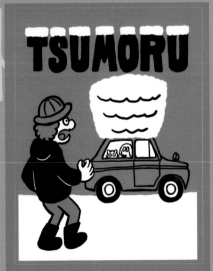

BREW YOUR MIND BREWERY
SZEKSZÁRD, HUNGARY

The first Brew Your Mind beer went on sale in 2015, and after a couple of years of brewing for hire, we moved back home to Szekszárd in 2018 to continue this journey in our hometown in our own brewery. Learning and continuous development of recipes is part of our everyday life. We are proud of our beers and the fact that we do what we love. After all, beer is not a goal, it is only a tool; and when it is combined with value, knowledge and enthusiasm, work becomes creation, function becomes experience.

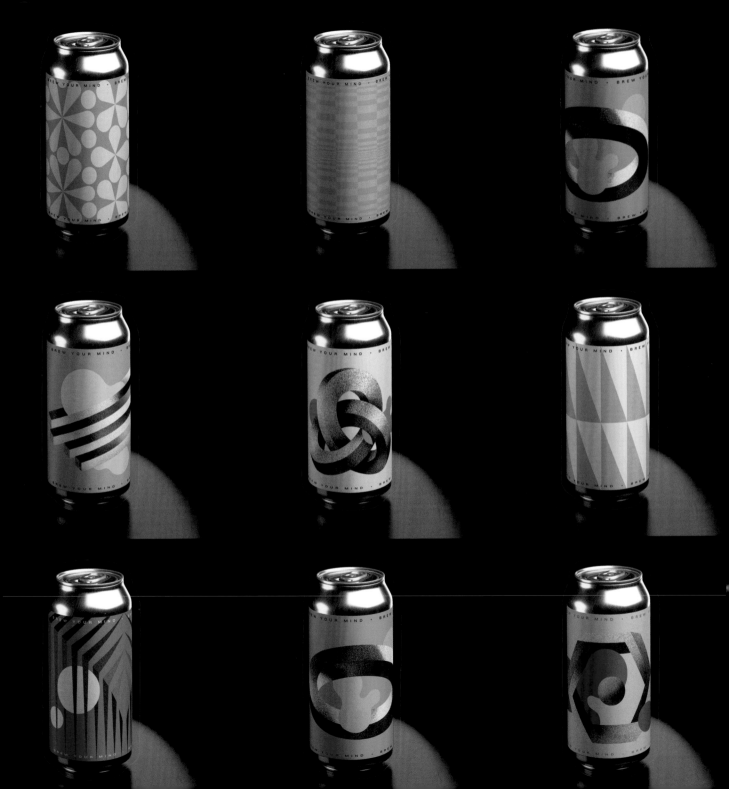

BURIAL BEER CO.
ASHEVILLE (NC), USA

Burial Beer Co. was dreamt up by friends Tim Gormley and Doug and Jess Reiser. Headquartered in beautiful, mountainous Asheville, NC, Burial's award-winning spectrum of beer spans a wide array of styles, ranging from modern, hop-forward IPAs to Lagers based on tradition; from adjuncted and barrel-aged Imperial Stouts to nuanced mixed-fermentation Wild Ales, and everything in between. In both 2021 and 2022, Burial was named Craft Beer & Brewing's Readers Choice #1 Small Brewery in the World.

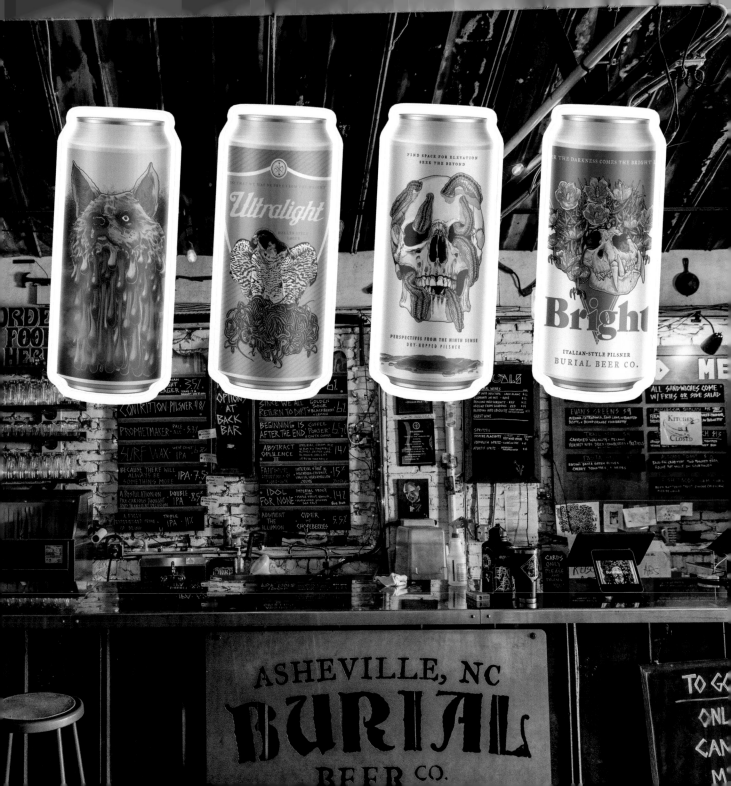

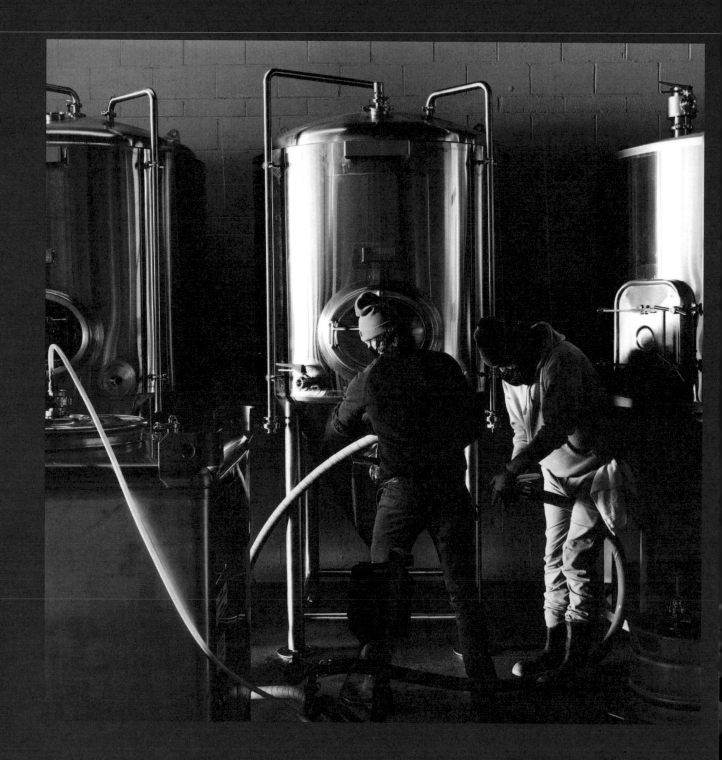

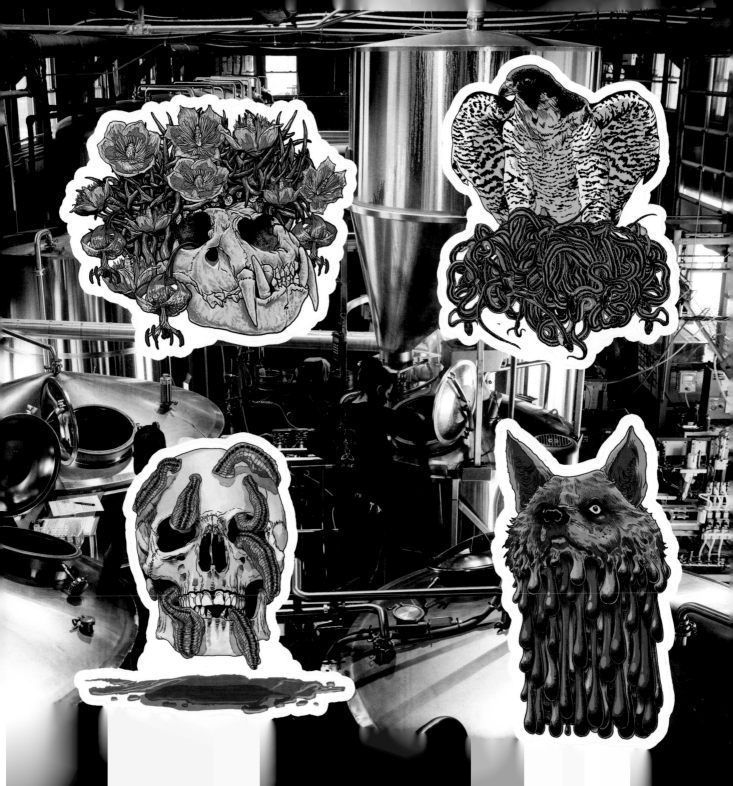

**carbon
brews**

CARBON BREWS
FO TAN, HONG KONG

The branding of Carbon Brews, an employee-driven brewery founded in 2018, is focused on reflecting the personalities of our people as a combination of adventurer (fearlessness, risk taking, focused, hungry for new experiences), artist (expressive, creative, unorthodox perspective) and citizen (stewardship, altruism, respect). From a design standpoint, we employ a clean, minimalist and modernistic style through our use of vibrant, even neon, colours, simple geometric shapes and abstract designs to highlight our edginess and boundary-breaking approach to our brewing.

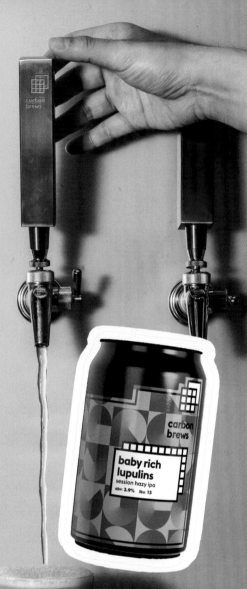

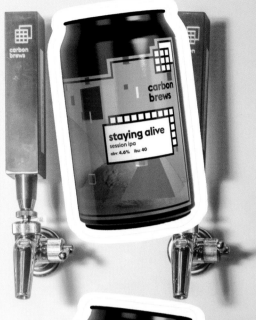

staying alive
session ipa
abv: 4.6% ibu: 40

carbon brews

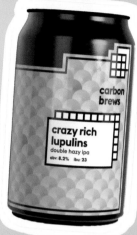

crazy rich lupulins
double hazy ipa
abv: 8.2% ibu: 23

carbon brews

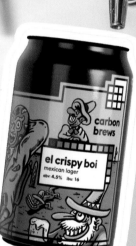

el crispy boi
mexican lager
abv: 4.5% ibu: 16

carbon brews

baby rich lupulins
session hazy ipa
abv: 3.9% ibu: 15

carbon brews

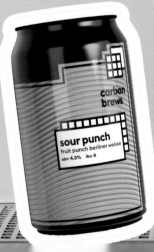

sour punch
fruit punch berliner weisse
abv: 4.5% ibu: 6

carbon brews

DOIS CORVOS
LISBON, PORTUGAL

Dois Corvos is an independent Portuguese brewery from Lisbon, set in the industrial neighbourhood of Marvila. Their graphic ID beams a no-holds-barred creative vibe in just about every direction. In these labels, you can see that there's space for some contained craziness, matching the diverse and multiple beers the brewery puts out throughout each year. The brand's name and logo were born from a 'local thirst' approach, as Dois Corvos (in English, 'two crows') are a symbol of the city of Lisbon.

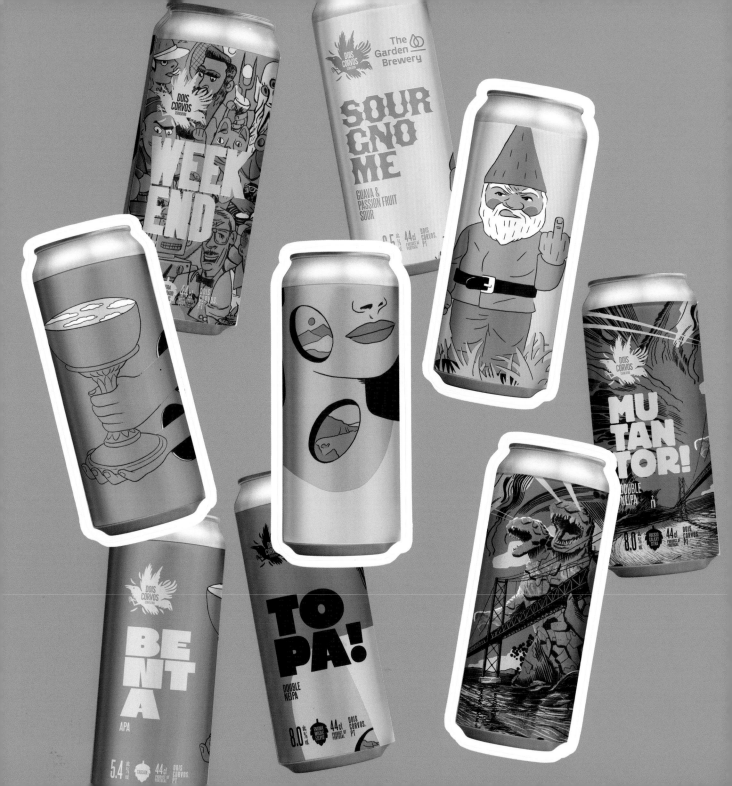

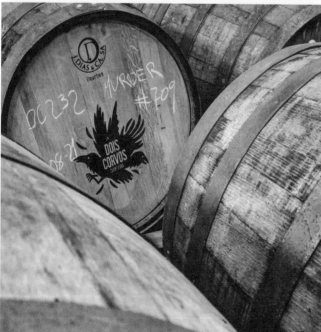

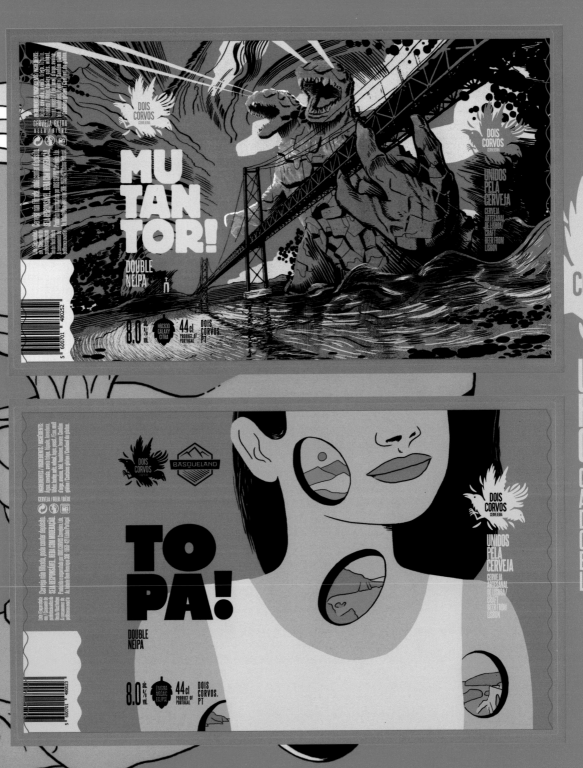

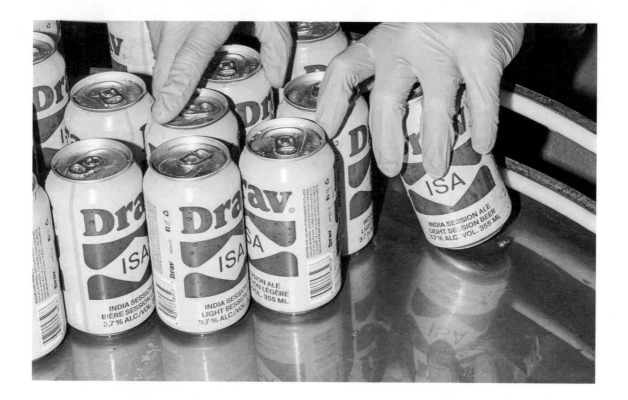

DRAV
CLERMONT (QC), CANADA

The one thing that we want is to create a must for hoppy beer and cocktail drinkers. With plenty of flavours, this great tasting beverage comes along with stories that'll make you thirsty. Drav is all about a super good alcohol company. Drav is meant for those chilling on the rooftop, in the basement or in the garage. It's for those whose left hand gets cold, but who never get cold feet.

INDIA PALE ALE
STRONG IPA BEER
6 % ALC./VOL. 355 ML

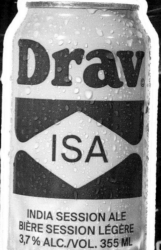

INDIA SESSION ALE
BIÈRE SESSION LÉGÈRE
3,7 % ALC./VOL. 355 ML

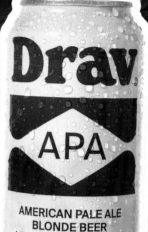

AMERICAN PALE ALE
BLONDE BEER
4.9 % ALC./VOL. 355 ML

INDIA PALE ALE
BIÈRE IPA FORTE
6 % ALC./VOL. 355 ML

INDIA SESSION ALE
BIÈRE SESSION LÉGÈRE
3,7 % ALC./VOL. 355 ML

PALE ALE AMÉRICAINE
BIÈRE BLONDE
4,9 % ALC./VOL. 355 ML

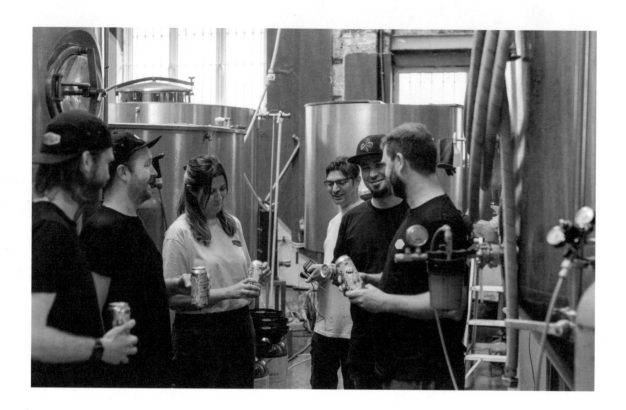

EXALE BREWING
LONDON, UK

Exale was established in 2019 and is based on the Blackhorse beer mile
in Walthamstow, London. They are the creators of the Iron Brew Sour, as
well as other experimental beers and beautiful hoppy, hazy beers. Exale are
multi-award winners, including Gold regional SIBA can awards and good
taste awards. In spring of 2021 the brewery rebranded with a fresh new look
from graphic designer Harold Bennett and illustrator Inga Ziemele.

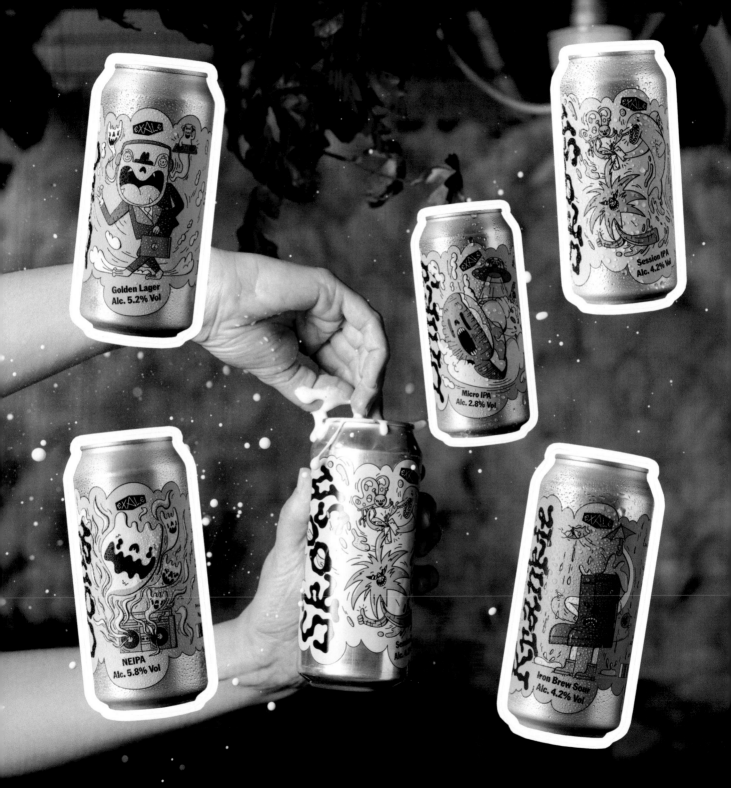

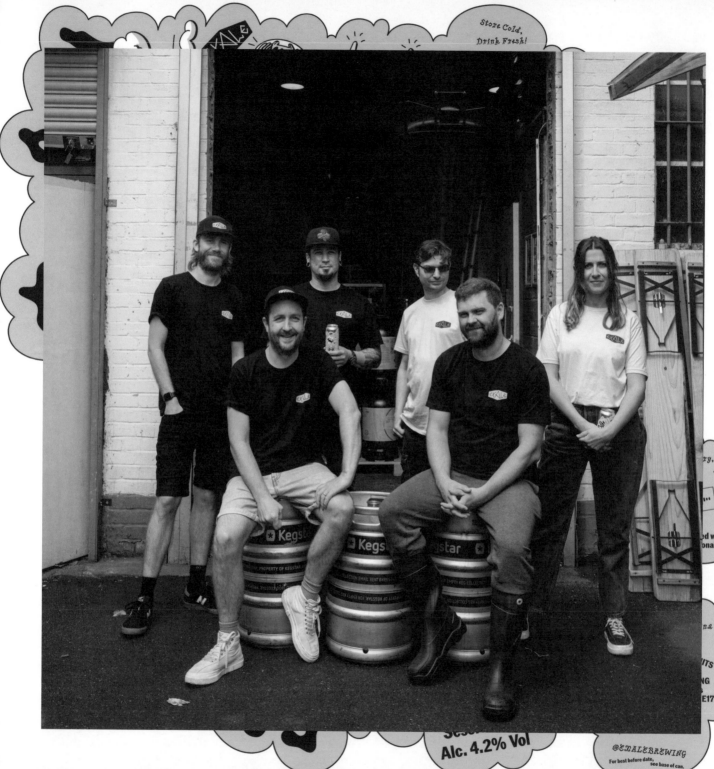

Store Cold,
Drink Fresh!

Se5...
Alc. 4.2% Vol

@EXALEBREWING
For best before date,
see base of can.

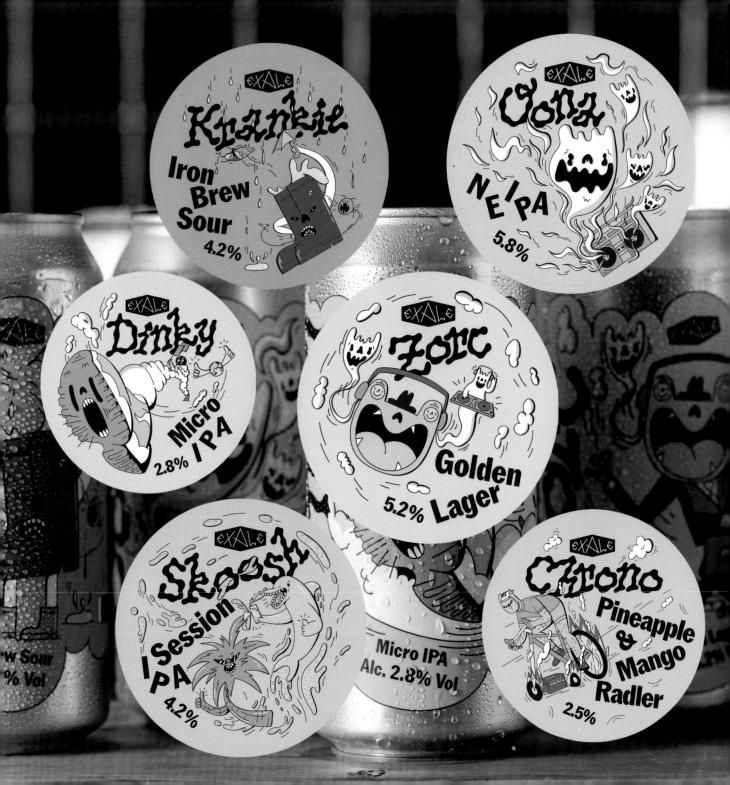

FRONTAAL BREWING CO.
BREDA, NETHERLANDS

Brouwerij Frontaal, a young innovative brewery from Breda. Founded in 2015, but already a household name in Breda, North Brabant, the Netherlands and Europe. We brew beer according to the philosophy that quality comes first. We make no concessions in the use of ingredients to achieve this. Moreover, balance in a beer is one of our main values, so we make sure that it is not all just about strength.

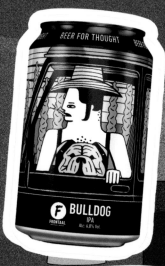

BULLDOG
IPA
Alc. 6.0% Vol.

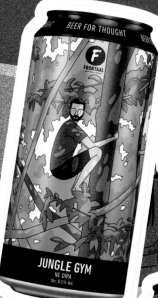

JUNGLE GYM
NE DIPA
Alc. 8.5% Vol.

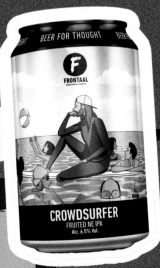

CROWDSURFER
FRUITED NE IPA
Alc. 6.5% Vol.

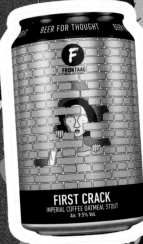

FIRST CRACK
IMPERIAL COFFEE OATMEAL STOUT
Alc. 9.5% Vol.

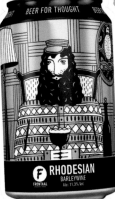

RHODESIAN
BARLEYWINE
Alc. 11.3% Vol.

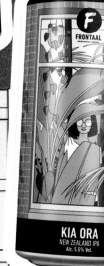

KIA ORA
NEW ZEALAND IPA
Alc. 5.5% Vol.

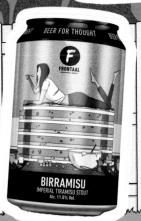

BIRRAMISU
IMPERIAL TIRAMISU STOUT
Alc. 11.0% Vol.

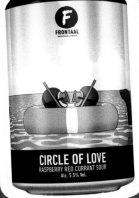

CIRCLE OF LOVE
RASPBERRY RED CURRANT SOUR
Alc. 5.5% Vol.

FUERST WIACEK

BERLIN

FUERST WIACEK
BERLIN, GERMANY

Fuerst Wiacek burst onto the Berlin craft beer scene in 2016 when they brewed Germany's first New England IPA. The opening of their new brewing facility in 2021 provided them with more opportunities for experimentation and innovation. Recent releases have included fruited sours, West Coast IPAs and stouts, and they have been steadily building a portfolio of classic styles. All this while continuing to deliver the consistently sublime, juicy, hop-forward IPAs beer lovers have come to expect from Fuerst Wiacek.

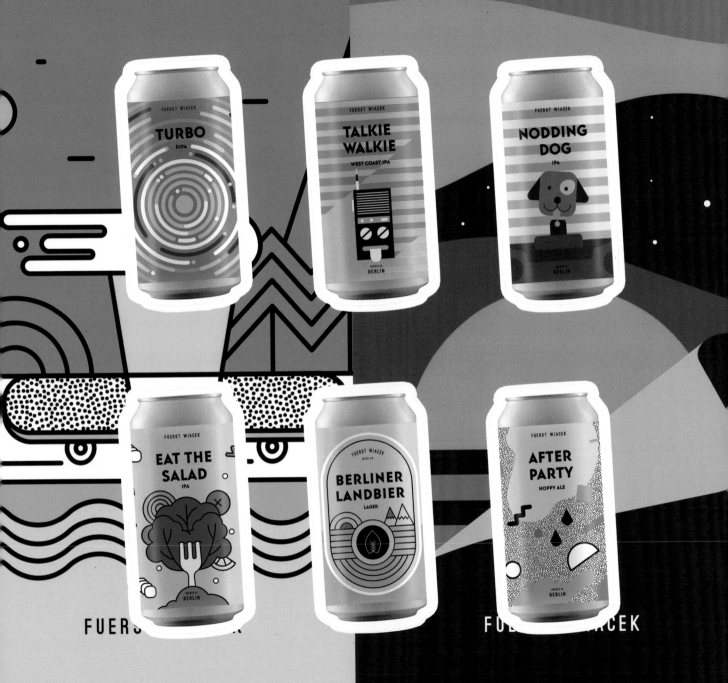

FUERST WIACEK

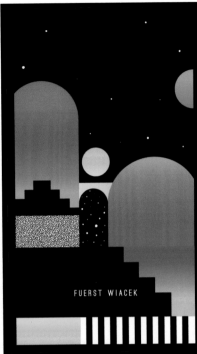

FUERST WIACEK

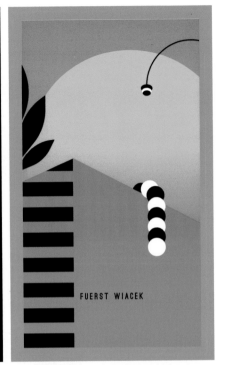

FUERST WIACEK

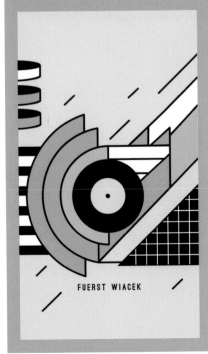

FUERST WIACEK

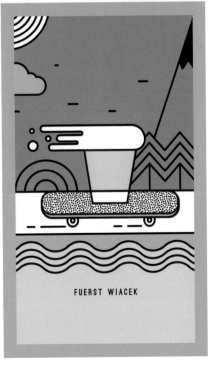

FUERST WIACEK

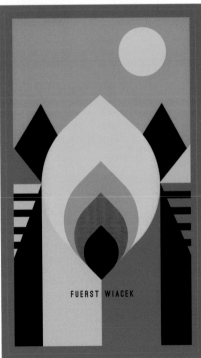

FUERST WIACEK

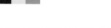

FUGU BREWING COMPANY
BRUSSELS, BELGIUM

Nico & Sam remember the tasting of their first homebrewed beers, and in particular the time when they had drunk a little too much while watching a documentary on this strange fish, the *fugu.* The journalist explained that it must be prepared with great care, and that in Japan cooking it is an art, the same as brewing a good beer. The link with beer was found! Fugu Brewing was born and this first explosively hopped New England IPA had a name, Fugushima.

GUAM BREWERY
TAMUNING, GUAM

Since 2017, our mission has been to brew fresh, local craft beer for the people of Guam and the Marianas that captures the Håfa Adai spirit in every pint. We brew a wide variety of beers so there's something for everyone. From IPAs to stouts, sours and everything in between - we're confident that we brew a beer that's perfect for you.

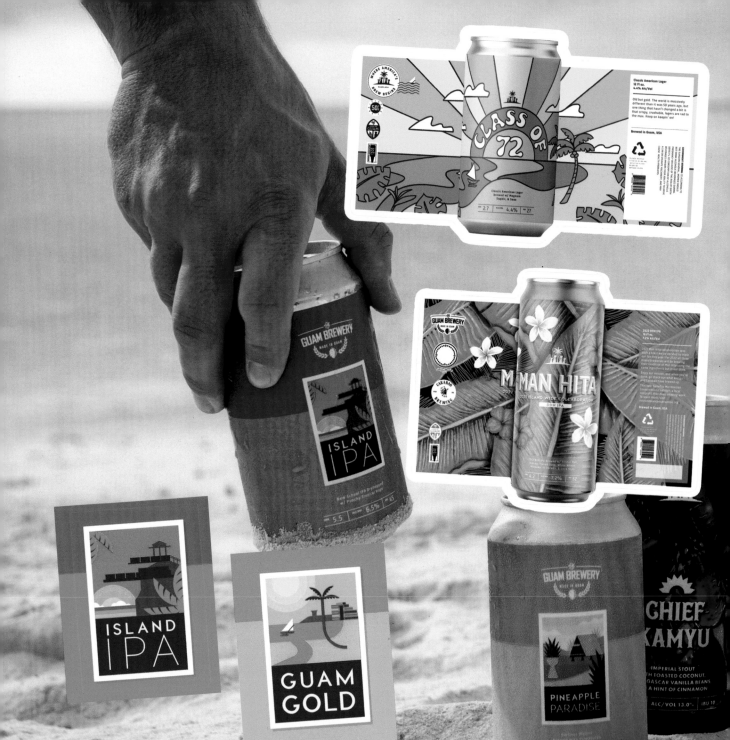

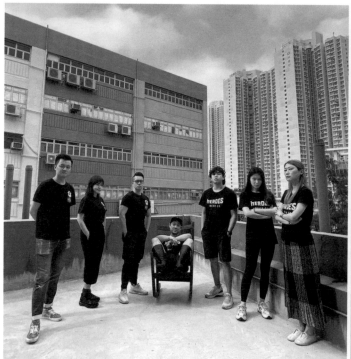

hEROES
BEER CO

HEROES BEER CO
YAU TONG, HONG KONG

We started hEROES in 2017 with our belief that everyone has the potential for greatness and heroism. Instead of just brewing beer, we built a platform where we unleash the hero within beer lovers. Our creation process starts with an in-depth interview with the individual beer lover, and his/her background, values and passions become the inspiration for the beer's recipe and design, as well as the beer hero's story. When you drink a hEROES beer, you are tasting and experiencing the beer hero's story, passion and superpower. We hope that by sharing these stories, we can inspire greatness in the beer community.

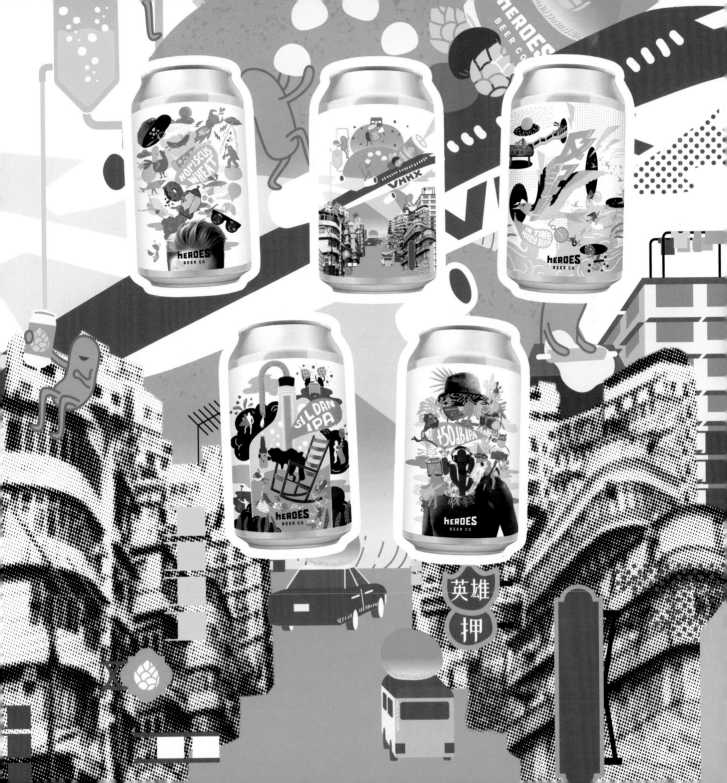

HOP HOOLIGANS

HOP HOOLIGANS BREWERY
BUCHAREST, ROMANIA

Hop Hooligans set out on a dangerous path in 2017, looking to brew the beer that they'd actually want to drink themselves - and they always liked powerful, flavourful, crazy stuff. Luckily it seems they weren't the only ones out there with the same mindset, so that meant they actually had to share their brews. Diana Barbu, their illustrator, who also lives and works in Bucharest, bought into the project with her vibrant, fun and feminine designs, and there's no limit for them now. Might as well join them!

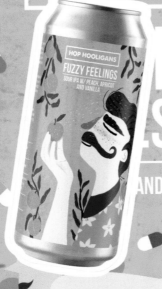

ANGRY JUICE

DOUBLE IPA

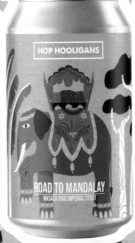

FUZZY FEELINGS

SOUR IPA W/ PEACH, APRICOT
AND VANILLA

HOP HOOLIGANS

ROAD TO MANDALAY

MASALA CHAI IMPERIAL STOUT

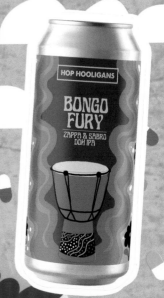

HOP HOOLIGANS

BONGO FURY

ZAPPA & SABRO
DDH IPA

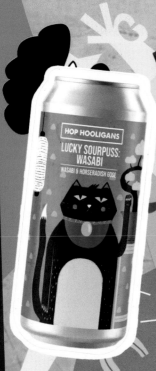

HOP HOOLIGANS

LUCKY SOURPUSS:
WASABI

WASABI & HORSERADISH GOSE

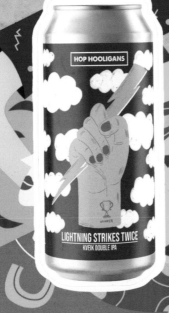

HOP HOOLIGANS

LIGHTNING STRIKES TWICE

KVEIK DOUBLE IPA

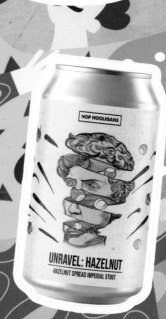

HOP HOOLIGANS

UNRAVEL: HAZELNUT

HAZELNUT SPREAD IMPERIAL STOUT

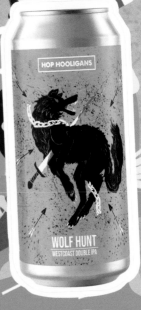

HOP HOOLIGANS

WOLF HUNT

WESTCOAST DOUBLE IPA

HOP HOOLIGANS

PUDGE

BLUEBERRY, RASPBERRY, BLACKBERRY,
STRAWBERRY, TONKA & CHOCOLATE
IMPERIAL SOUR ALE

HOP HOOLIGANS

COSMIC CATTLE
DDH NEIPA

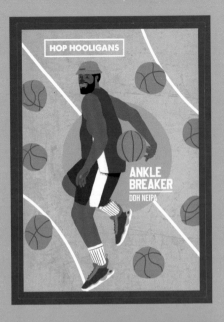

HOP HOOLIGANS

ANKLE BREAKER
DDH NEIPA

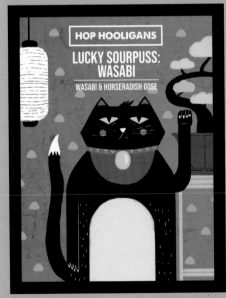

HOP HOOLIGANS

LUCKY SOURPUSS: WASABI

WASABI & HORSERADISH GOSE

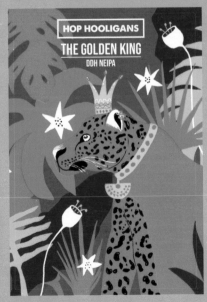

HOP HOOLIGANS

THE GOLDEN KING
DDH NEIPA

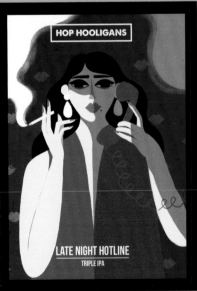

HOP HOOLIGANS

LATE NIGHT HOTLINE
TRIPLE IPA

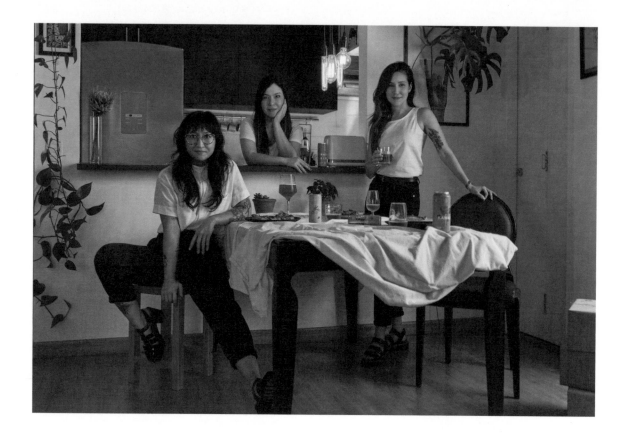

JAPAS CERVEJARIA
SÃO PAULO, BRAZIL

We are a Nipo-Brazilian brand. We're proud of our origin and in it we seek inspiration for our creations. *Japas* is a term widely used in Brazil to describe us, since we are Asian descendants, and sometimes that can happen even without people asking for our permission. We decided to resignify and reappropriate this adjective. After all, if the place of speech is ours, the word must be ours too, right? So, let it be used with pride and to represent who we are: Japanese-Brazilian.

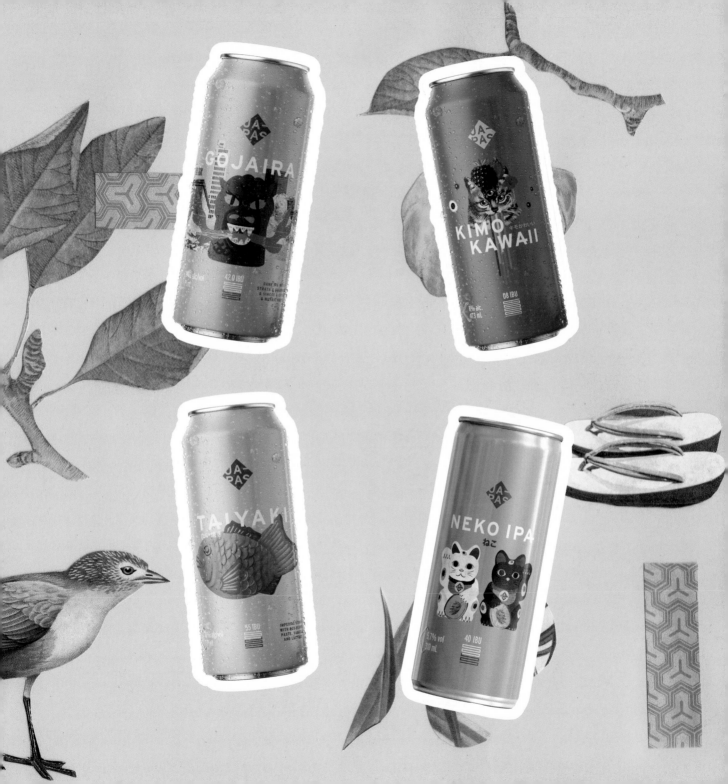

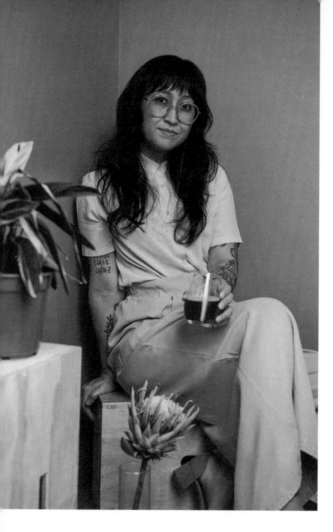

when the beer was ready we tasted it together and everyone's favourite was the version with *wasabi*. We posted on our social media and got invited to brew this recipe at Cervejaria Nacional, a brewpub in São Paulo, a 700-litre batch. The release party was on a Monday, the brewpub was full, and the beer sold out in a couple days. We were super happy with the result and we decided to take Japas to the next level and opened a company together. In 2015 we started contract brewing in Brazil and since then we've been creating different beers to celebrate our origins. Following our success in Brazil, in 2019 we started contract brewing in the US too, and nowadays we distribute in 10 US states: CA, FL, MA, ME, MI, NY, OR, PA, RI and WI.

How did you approach building and growing the brand's visual identity?

Creating Japas Cervejaria brand was a natural process of self-realisation for all of us. We had a lot in common, being of Japanese descent as well as women participating in a predominantly masculine field. When we were choosing our name, we initially thought of creating a name with Japanese words and concepts, but many people would simply forget it because it would be difficult to pronounce, so they would end up calling us *Japas*. For this reason we decided to appropriate the word and to use it with pride. From that, I created the logo that represents a combination of the flags of Brazil and Japan: the idea was that it would be a contemporary logo that would work in many ways for our company as well as being a timeless symbol.

The idea is to show that we are a Japanese-Brazilian brand, resignifying our origins through our creations. Our goal is to share with the public who we are and who we have become because of this mix, not only by making products, but by telling stories. Thus, our look is based on Japanese design, but with a touch of Brazil, avoiding traditional Japanese stereotypes. Our visual language, brand voice and colours also deviate from the traditional beer market, and we like to communicate more freely as if we were talking directly to people ourselves, in a fun, light and friendly way, but also assertively, to make sure people understand what we do. We are also open in our palette and use different colours in our communication, conveying diversity and free expression.

Interview with designer and collagist Yumi Shimada

How did you all start working together?

It was quite natural the way we got together. In 2014 there were even fewer women working in craft beer, and on top of that we had our Japanese ancestry in common, so we were usually together at pubs and beer festivals. One day we decided to make a homebrewed beer to honour our origins. We chose four different Japanese ingredients to test and brewed an American Pale Ale as the base beer in some homebrewing equipment, and

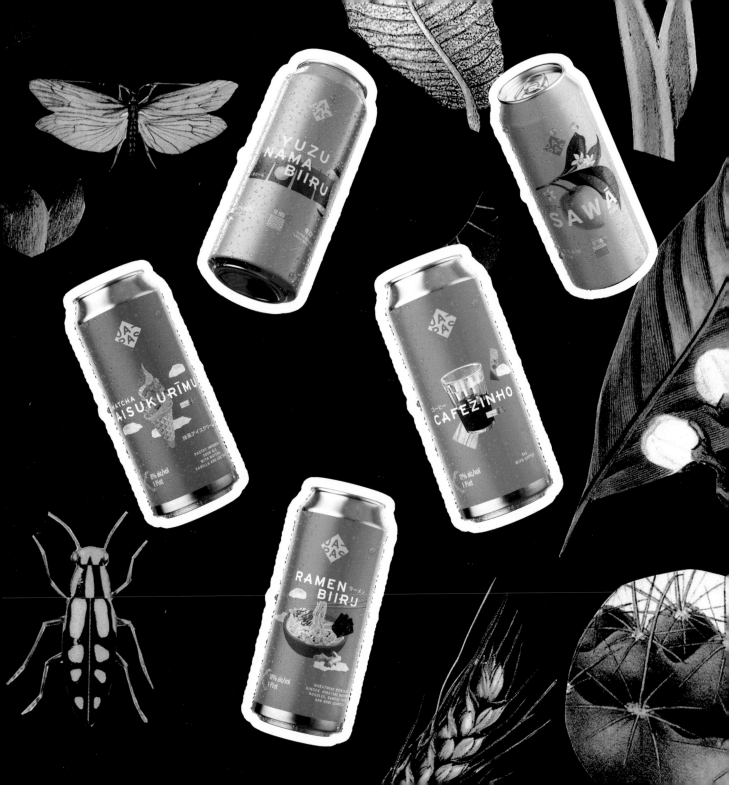

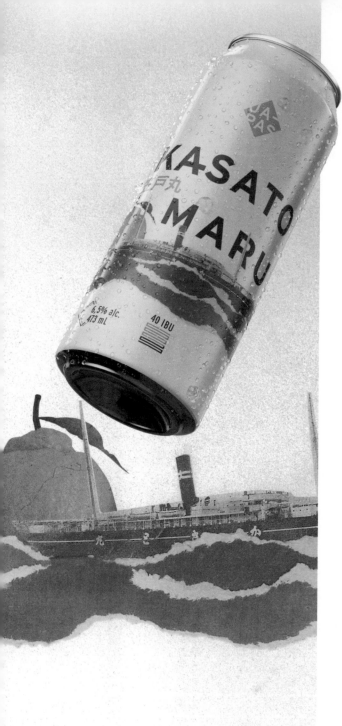

As for the art of the labels, as I am a collagist, I saw a way to differentiate ourselves on the shelves using the collage technique. Usually this is digital, but in special cases I produce it manually with clippings of images taken from my collection of books.

All of the partners cooperate in the entire creative process, and we believe that this union is what makes the brand stronger and more consistent. Each of our creations is the result of an exploration of our common ancestry, which is a blend rich in aromas, flavours and culture, producing recipes that celebrate the union between Brazil and Japan in a contemporary way, without clichés or pre-established ideas.

Which is your favourite beer can design and why?

My favourite label is Kasato Maru, named after the first ship that brought Japanese immigrants to Brazil. The beer was launched in celebration of 110 years of Japanese immigration to our country, referring to this milestone in our history, and containing an ingredient that also relates to our ancestors because, like them, it came from Japan and has adapted to Brazilian soil. All this representativeness helped to connect us even more with the Japanese community here.

On the label we explain: 'On June 18, 1908, the first Japanese immigrant ship landed in Brazil, marking the beginning of an influence that contributed so much to our cultural formation here. An IPA, refreshing and hoppy, with the addition of *dekopon*, a tangerine of Japanese origin that also arrived as an "immigrant" to our country.'

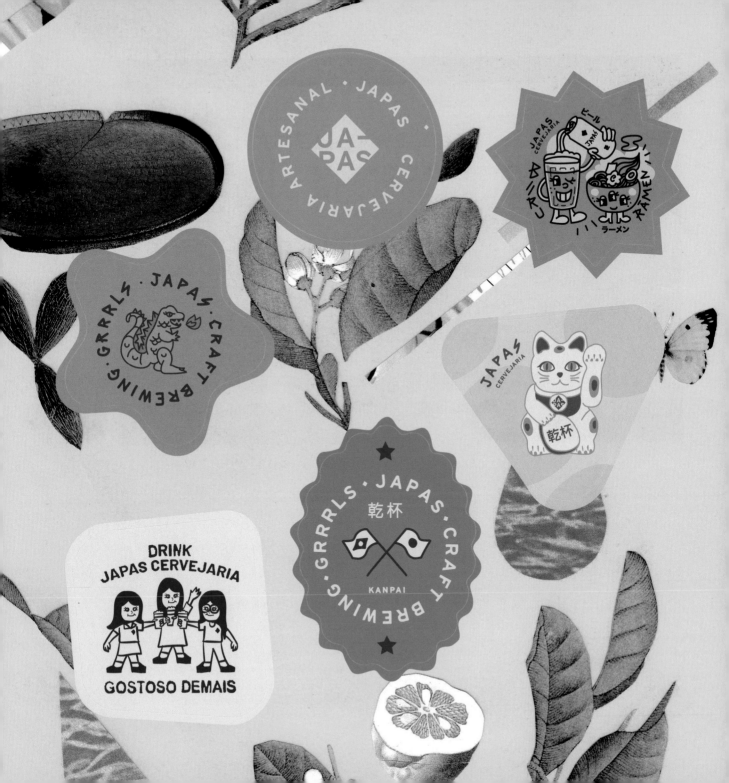

LA SOURCE BEER CO.
BRUSSELS, BELGIUM

Based in Brussels, La Source is an artisanal & creative microbrewery, founded by partners in life, Nina Carleer & Mathieu Huygens, and active since October 2019. IPAs, sour & wild beers, seasonals, barrel-aged or classic styles revisited make up the variety of La Source's production. The beers are available in cans to take away, or to be enjoyed at the bar directly from the source! Nina Carleer creates all the visuals for the brewery, engraving & printing for their numerous new recipes. Enjoy her colourful universe of animals!

LA SOURCE BEER CO.

FREE

ONE
SORACHI ACE LAGER

E

VIPÈRE
— SOUR IPA —

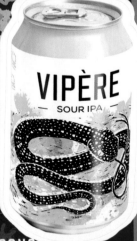

CONCERTS
LA JUNGLE +
ERINÏGOLEM +
ACHYCARDIE +
ANSE MUSIQUE
-ALPES + SVÆR

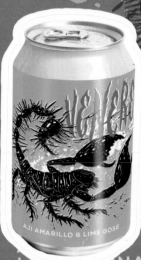

AJI AMARILLO & LIME GOSE

LES JAPONAISE
KAMIKAZÉ + REVSUS VERSUS S

LIÈVRE
- IPA -

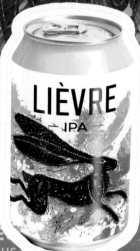

8.04
EU
WÆR
VEN

5.04
AN
SCORE

20.05
CHOCOLAT BILLY
DON VITO + BUGINCAN

HYDRE, | ELDERFLOWER PALE ALE

KEEP in the FRIDGE DRINK NOW

JET LAGER | DRY HOPPED LAGER

KEEP in the FRIDGE DRINK NOW

BRAINED ROBOT

+ DUKE

DISCO DINO | COFFEE & RASPBERRY SOUR

OBSIDIAN | BLACK DIPA

KEEP in the FRIDGE DRINK NOW

+ DUKE +

LA MEUTE | HAZY IPA

KEEP in the FRIDGE DRINK NOW

HIGH TIMES | DDH PALE ALE

HIGH TIMES

KEEP in the FRIDGE DRINK NOW

LA SOU

CO

OT

OES

MEGOBREBI BREWERY
TBILISI, GEORGIA

Megobrebi Brewery is a Georgian new wave craft brewery specialising in sour, hybrids and unique beers, inspired by regional qvevri style wines, local ingredients and traditional Georgian cuisine. We have no rules for creativity, no boundaries, no regrets. The only thing in which we are conservative is that we truly believe in friendship and *megobrebi* (Georgian for 'friends'). Our mission is to integrate Georgia into the internationally recognised craft beer scene.

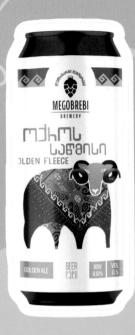
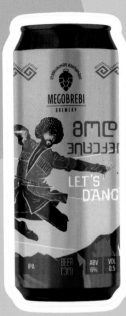
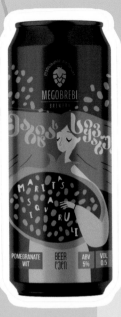
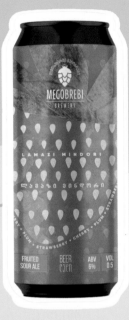
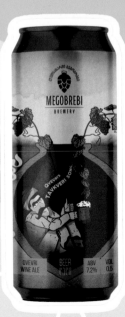
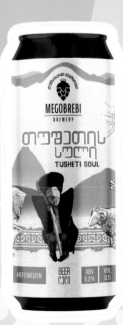
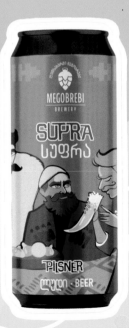
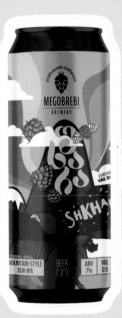

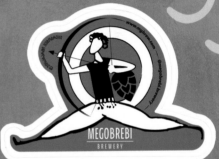

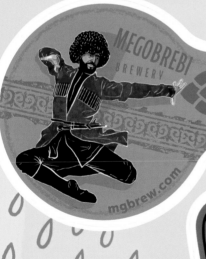

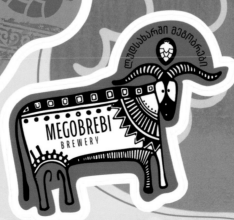

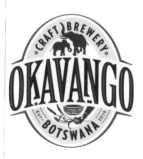

OKAVANGO CRAFT BREWERY
MAUN, BOTSWANA

Established in 2020, the Okavango Craft Brewery is Northern Botswana's
first licensed microbrewery. We produce award-winning craft beer from
the finest quality ingredients, including locally sourced millet from
elephant-friendly subsistence farmers in the Okavango Delta. Join us on
our journey to brew for conservation.

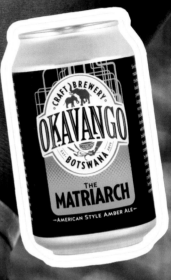
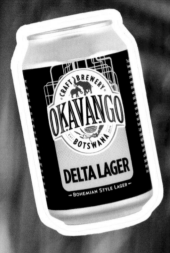
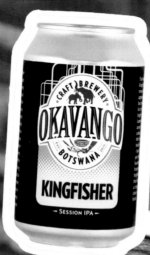
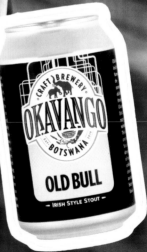
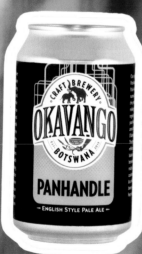
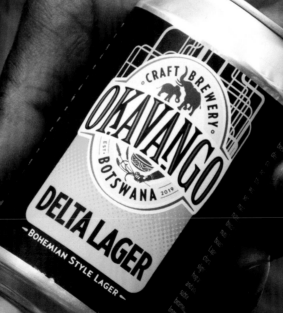

Interview with Murray Stephenson, Head Brewer

You are the first brewery in Botswana to use local products - how have you been received domestically, regionally and even internationally?

In an area that has never been exposed to craft beer, the initial reception has been good although a little tentative. As we have more opportunity to get people in to try our beers and hear about how and why they're made, they are usually very excited about trying new flavours in beer. The region is also very happy to have a brewery they can call their own.

And what does sourced locally entail?

We buy millet, a grain that grows well in the arid areas of Northern Botswana, from elephant-friendly farmers. These farmers are based in the Panhandle region of the Delta and have entered into a program with an NGO called Ecoexist. Ecoexist facilitate the

farmers with field protection and conservation farming practices. We buy the excess millet at a surplus price from these elephant-friendly farmers as a way of rewarding them for their farming practices. This millet is then malted on site in Maun and used to produce a range of beers.

Regarding the artwork for Okavango - how did that come about? Who produced it and what was the process?

We wanted a logo that would tell our story so calling it 'Okavango' was a no-brainer seeing as the beers are brewed in the Okavango Delta. The images on the logo include a woman's hand holding the millet to represent the farmers we work with in the Panhandle, the majority of whom are women. Then we depict the elephants that we aim to conserve by working with the farmers. Our beers are named after different elements of the delta, such as the area, the delta waters and the animals that call it home.

What do you feel is unique about your beers?

Our beers are unique because they are brewed using millet that is sourced locally in an effort to support farmers and conserve wildlife. Not many breweries use millet to produce beer, so not only is it a unique story, it also adds a unique flavour and aspect to the beer. We are currently Botswana's only craft brewery, which already sets us apart from other beer in the country. Then we are also unique as we are based in the Okavango, a very remote and rural area.

Who are Kuru Art and what's behind your collaboration with them for your new beer The Kiwi and the Ostrich?

We started a single-batch series with the idea of collaborating with a local artist on each label. The first in that series was also a collaboration with a New Zealand hop farm, Freestyle Hops, that we named 'The Kiwi and the Ostrich'. We thought that Kuru Art Project would perfectly suit the feel of the beer. They work with artists from the San community in a small village of Western Botswana. The San people are known for their nomadic, hunter-gatherer culture. The Kuru Art Project gives a voice to the San people to express and communicate elements of their culture, which is rapidly disappearing. The label we produced with artist, Gamnqoa Kukama, perfectly tells the story of 'The Kiwi and the Ostrich'.

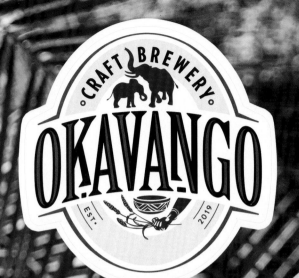

CRAFT · BREWERY
OKAVANGO
· EST · 2019

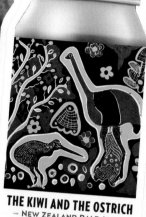

THE KIWI AND THE OSTRICH
— NEW ZEALAND PALE ALE —

marula
sour
ale.
BARREL AGED

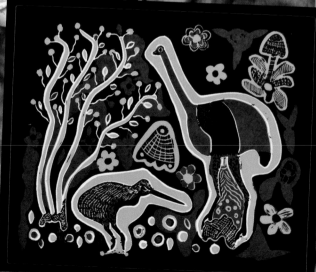

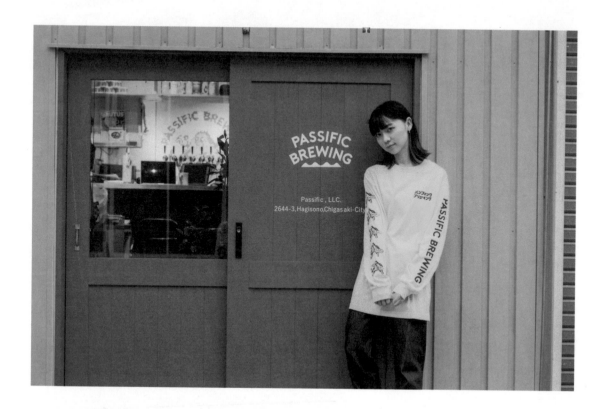

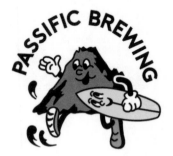

PASSIFIC BREWING
CHIGASAKI, JAPAN

Passific is a brewery that journeys, through its beers, across oceans and mountains. Passific is a combination of the words 'Pass' and 'Pacific'. The name is derived from our roots in both the sea and the mountains. We cherish the connections with people, towns and nature that we encounter on our travels. We will continue to brew beers that bring them all together.

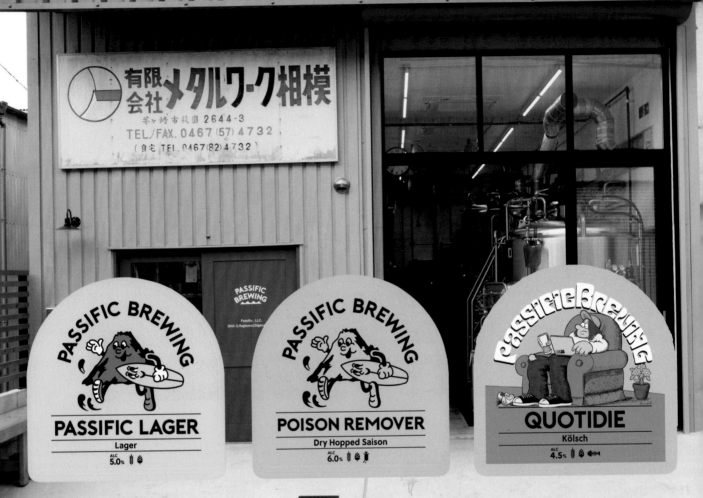

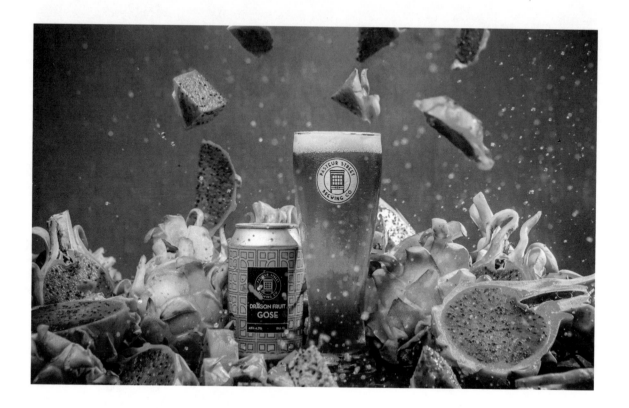

PASTEUR STREET BREWING COMPANY
HO CHI MINH CITY (SAIGON), VIETNAM

Headquartered in Saigon, Pasteur Street Brewing Company brings together innovative craft brewing techniques with fresh, local Vietnamese ingredients. Since serving our first beer in January 2015, we have become more than just a brewery. Pasteur Street has become a lifestyle brand and a leader in the South East Asian craft beer community. We pride ourselves on experimentation while always keeping craft at the core. Look for our award-winning beers throughout Vietnam and the world.

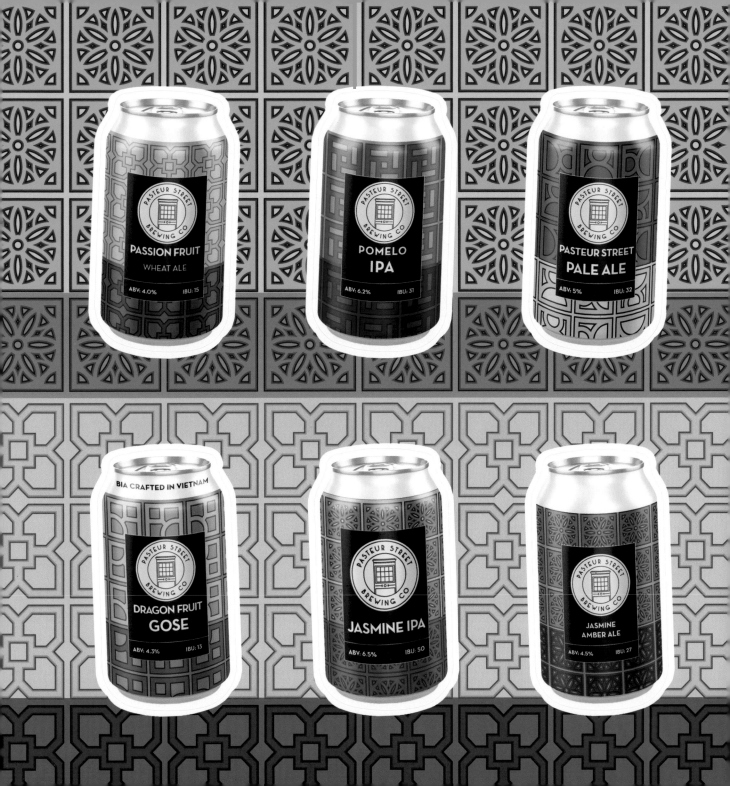

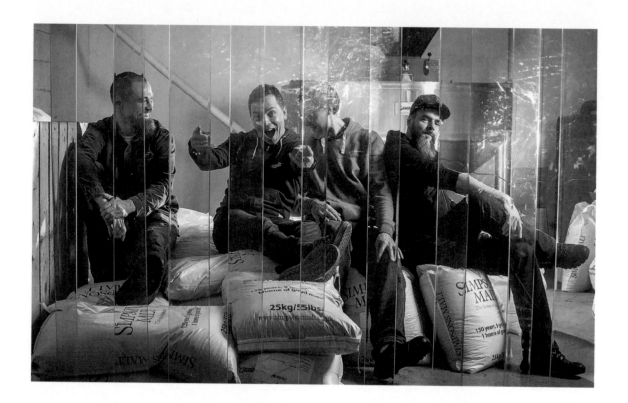

PÜHASTE BREWERY
TARTU, ESTONIA

The origin of Pühaste Brewery goes back to the year 2011, when the first test beers brewed by Eero, our head brewmaster, in the summer cottage in Pühaste village, earned acclaim from his friends. Further brewing as a 'gypsy' brought a lot of good feedback from the wider craft beer community in Estonia as well as abroad. In 2016 we opened our own production facility in Tartu. We brew a wide range of styles from lagers to IPAs and strong dark beers to wild ales. Our beers are available in more than 35 countries in Europe and beyond. Label art is created by Estonian artist Marge Nelk.

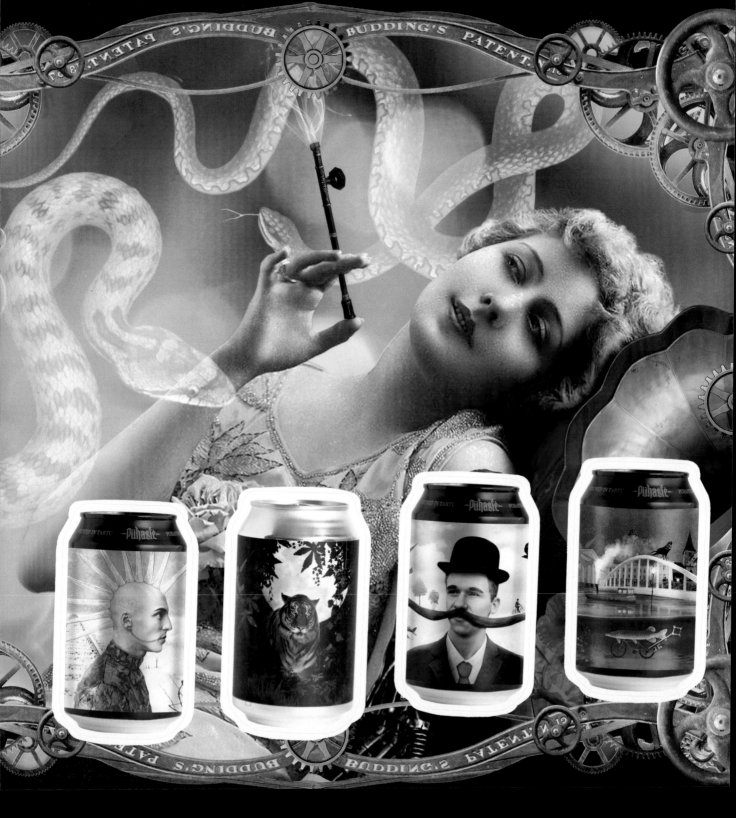

REUBEN'S BREWS
SEATTLE (WA), USA

We opened Reuben's Brews in 2012, following Adam's award-winning homebrewing career, naming the brewery after our first child, Reuben. At our family brewery we brew from the glass backwards: designing each beer with intention, unbound by constraints. We know making that extra effort is worth it. From your everyday favourite beers to our innovative new releases, we help you grow your love of beer.

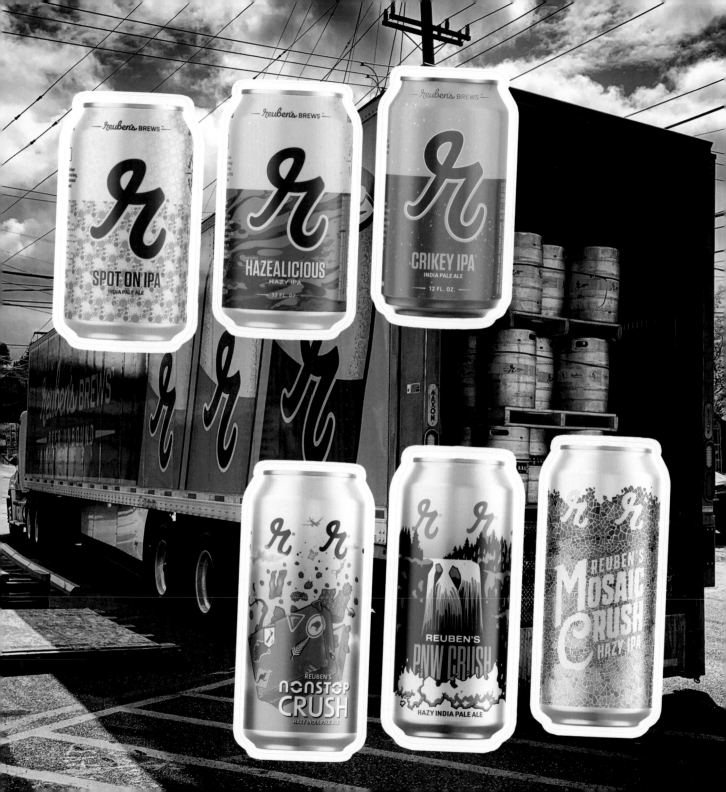

SURESHOT BREWING
MANCHESTER, UK

Sureshot Brewing is all about bringing joy to beer. We take beer seriously, but not ourselves. Founded in 2020, Sureshot has been a long term project of James Campbell. His experiences as head brewer at some of Manchester's most respected independent breweries, and in pioneering new styles and different hops from across the world, means that JC has been instrumental in the development of new wave British brewing. We focus on what we know people love: hoppy IPAs, clean lagers, and flavourful, easy-drinking pale ales. High quality, small batch - from the belly of Manchester. Drink it like you stole it. Get fatter than Jesus.

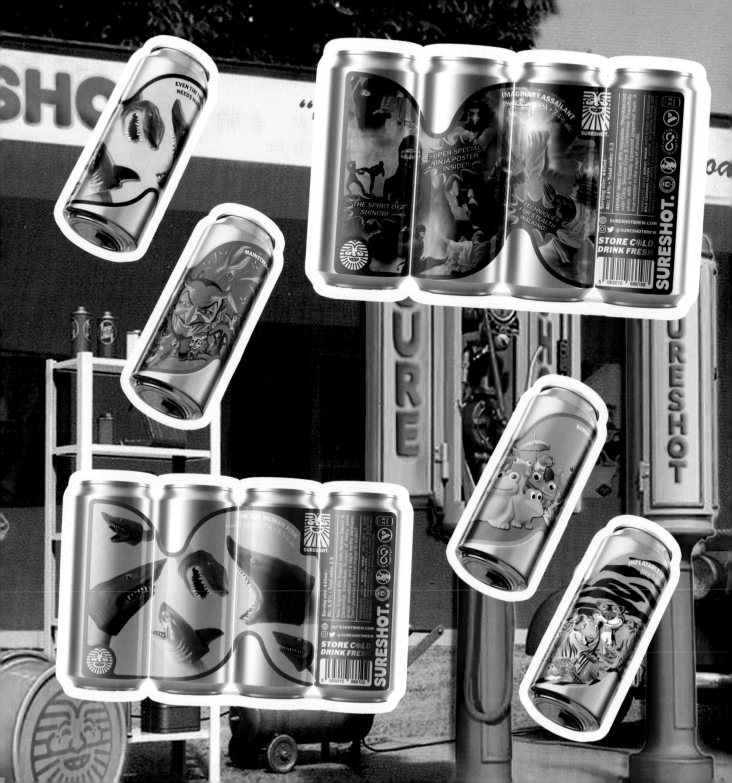

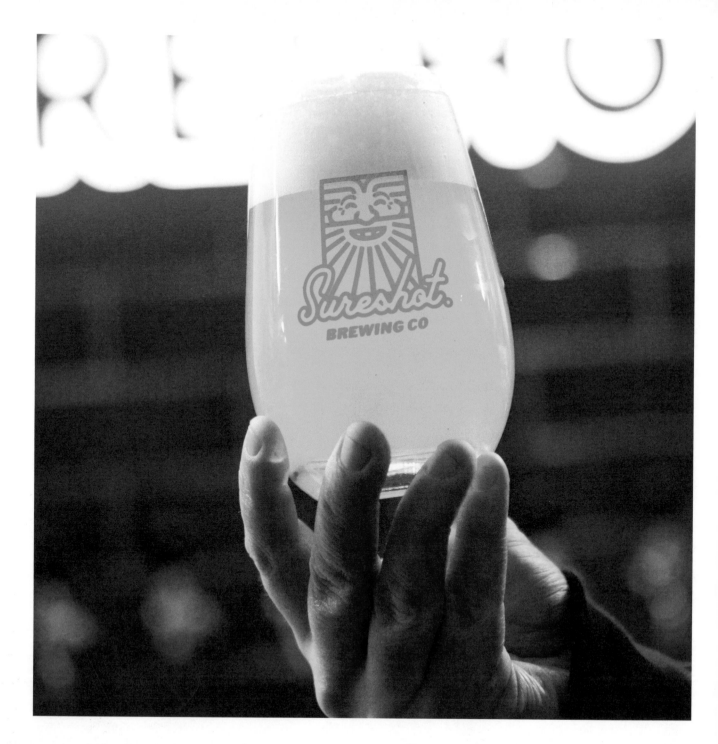

TO ØL
SVINNINGE, DENMARK

To Øl is a young Danish craft beer brewery established in 2010. When To Øl was founded, we were sick of hundred-year-old breweries claiming territory only due to their antiquity, and instead we wanted to give beer some youth. At To Øl we do contemporary beers. We brew a wide range of potent, provocative, fresh and floral beers; hoppy, balanced and complex beers that are light, dark, strong and simple. We brew the beers we want to drink ourselves and aim to produce the best beers in the world.

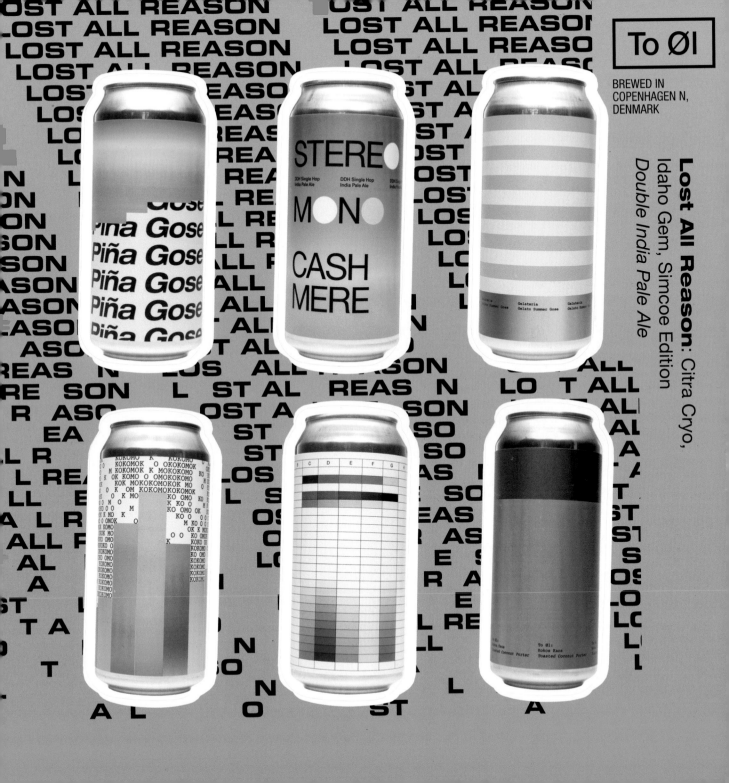

I met the founders of To Øl back when we attended the same high school in the Nørrebro area of Copenhagen. They started to experiment with brewing in the school's kitchen and needed some labels for their first bottles. Since I was the only person they knew doing a bit of graphic design, they asked me to do the first labels. We made them on the school's xerox machine. I have been onboard ever since.

I don't have a specific process for generating ideas. It is all really fluid and negotiable. I'm influenced by a wide palette of references, from quantum mechanics to modernist Italian avant-gardes, and from utilitarian architecture to contemporary graphic design.

To Øl don't really have a fixed visual identity. It is a constant negotiation of what a beer and its surroundings can look like. Most theories on visual identities have been developed to suit major public or corporate institutions like banks or ministries where coherence and authority are key factors. I think that a craft brewery operates in a different way, and thus we don't need to adhere to the same principles. The most important part of our design and style guide is a playlist containing tracks that have influenced To Øl's visual output in one way or another.

Kasper Ledet
Art Director and Graphic Designer, To Øl

SLOOPKOGEL SLOOPKOGEL SLOOPKOGEL... (repeated pattern)

SLOOPKOGEL
TIPA

A wrecking-ly juicy triple IPA

To Øl

BREWED IN
TO ØL CITY, DENMARK

To Øl

BREWED IN
COPENHAGEN N,
DENMARK

Icon
West Coast IPA

Hopped with Chinook,
Centennial & Simcoe

the silhouette of a palm tree

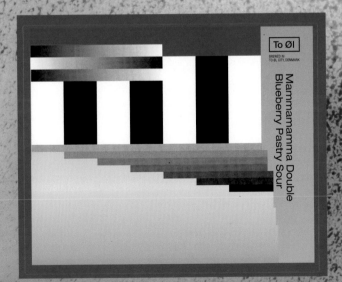

To Øl

BREWED IN
TO ØL CITY, DENMARK

Mammamamma Double
Blueberry Pastry Sour

LOST ALL REASON LOST ALL REASON... (repeated pattern)

To Øl

BREWED IN
COPENHAGEN N,
DENMARK

Lost All Reason: Citra Cryo,
Idaho Gem, Simcoe Edition
Double India Pale Ale

Bjørn Svin - Heated & Muted
Nothing in the world of techno has ever sounded quite like Bjørn Svin's nineties output.

Aphex Twin - Avril 14th
A little Eric Satie inspired composition for automated piano.

Technotronic - Pump Up The Jam
The high water mark of late eighties / early nineties dance music.

Philip Glass - Sand Mandala
The master of minimalism goes east.

New Order - True Faith
A deep song about drug abuse disguised as a dance track and packaged in one of the most beautiful record sleeves ever designed.

Van Halen - Eruption
The guitar hero Eddie van Halen being his most guitar heroesque.

Düreforsög - Monkation
An unholy alliance of black metal and funk.

D-A-D - Sleeping My Day Away
Danish hillbilly eighties glam rock with one of the most powerful chorosus ever made.

Kraftwerk - Computer Love
A hauntingly beautiful track, foreseeing the loneliness of the internet age.

Palle Mikkelborg - Prince of Peace
Nordic jazz has been ridiculed for too long. Forget your prejudice and enjoy this masterpiece of trumpets, synths and tons of reverb.

Robert Miles - Children (Dream Version)
Italian drama meets British house. The black and white music video was also refreshingly different.

Motörhead - (We Are) The Roadcrew
Lemmy and gang's wild tales from life on the road.

Grace Jones - Pull Up To The Bumper
A very cool track by the empress of cool.

Underworld - Two Months Off
The Dire Straits of techno never fails to deliver.

Björn Afzelius - Tusan Bitar
Larger than life Swedish pop music at its best.

Massive Attack - Safe From Harm
The city of the late twentieth century is a cold and alienating place.

Madonna - Like a Prayer
A gospel choir and the queen of pop was a match made in heaven.

Brian Eno - An Ending (Ascent)
Cinematic country-space-ambient.

Bjørk - Hyperballad
Starts out pretty low key and evolves into a full blown dance track. Michel Gondry also did a nice music video.

This Mortal Coil - Song To The Siren
Postmodernism has never sounded as majestically beautiful.

Everything but the Girl - Missing (Todd Terry Remix)
The curious combination of a British indie band and an American house producer created one of the most memorable tracks of the nineties.

Miles Davis - Pharoh's Dance
A fever dream, a beatiful fever dream.

Lust for Youth - Armida
This track has mainly been circling the Copenhagen underground but sure has the potential for international fame.

Faithless - Insomnia
This is house music's equivalent to Black

Sabbath's Iron Man. One of the most iconic synth riffs ever recorded.

David Bowie - Warszawa
The quintessential soundtrack to the dark side of modernism.

Younger Brother - Psychic Gibbon
Psytrance meets The Cure.

The Knife - Silent Shout
Raving in the cold windswept remove of the Swedish tundra.

Music recommendations - We often talk about music when discussing design at To Øl. Somehow music seems as the ultimate art form tapping directly into our emotions in an elegant abstract manner. Here is a selection of tracks that is dear to the design department at To Øl. This selection can hopefully also help to shed further light on To Øl's design decisions.

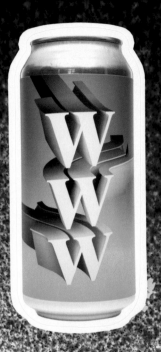

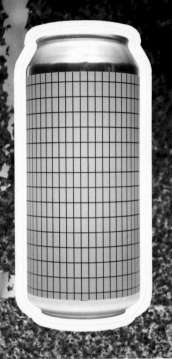

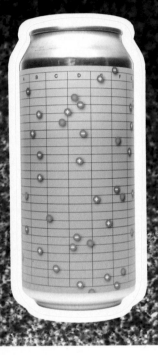

World Wide Westcoast

The initials of the name are extruded to form abstract structural elements. I like that this, in a very literal sense, exposes the deep connection and sometimes interchangeability of graphic design and architecture. Cities have become images and letters have become buildings… (CGI by Michael Madsen)

Das Kølich

A modernist grid referencing some of the buildings designed by great German architects like Mies van der Rohe and Walter Gropius is floating on top of a corny gradient from the local tanning salon. I like how the aesthetics of international style modernism crashes with a seemingly less valued visual language. I do, however, think that both expressions are part of my visual DNA.

Atomic Dog

A formalist artwork is composed in a spreadsheet. Spreadsheets are an important part of making beer, from planning and administration to logistics and warehousing. Obviously hops, grains, and fermentation tanks are also important, but they have been portrayed so often on beer labels. I like to shine a bit of light on the often overlooked importance of spreadsheets. They are also quite beautiful in a subtle kind of way.

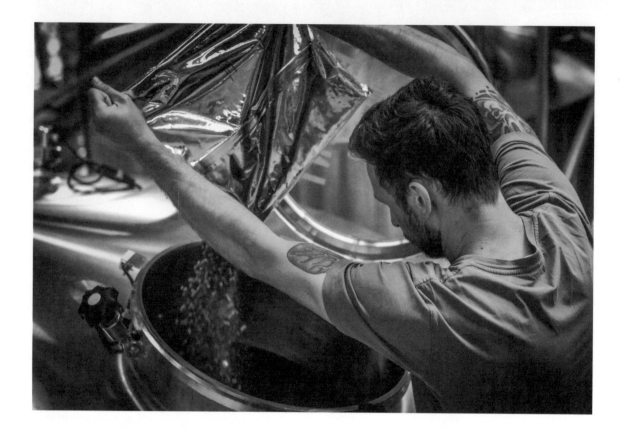

VERDANT

BREWING CO.

VERDANT BREWING CO.
PENRYN, UK

Verdant Brewing Co. began life back in autumn 2014 near Falmouth, Cornwall. Since then, nothing's changed. It's still about taste, quality, and all round deliciousness. Over the past few years, they've become synonymous with hop-forward beer styles including Pale Ale, IPA & DIPA. Their ethos revolves around brewing the flavour-packed beers they love to drink, and ensuring that beer lovers have access to delicious, quality-driven releases week after week. Being independent enables them to stay ethical and sustainable, and to keep pushing the boundaries of taste and quality.

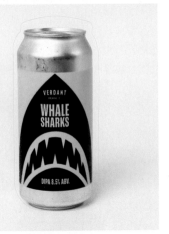

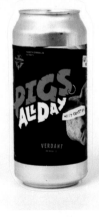

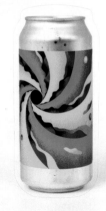

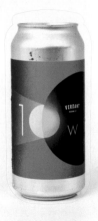

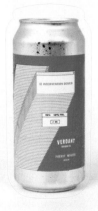

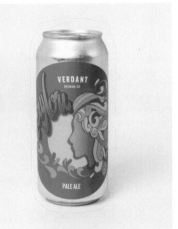

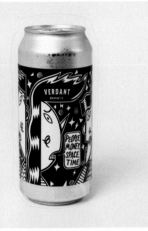

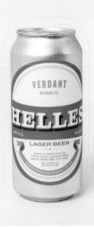

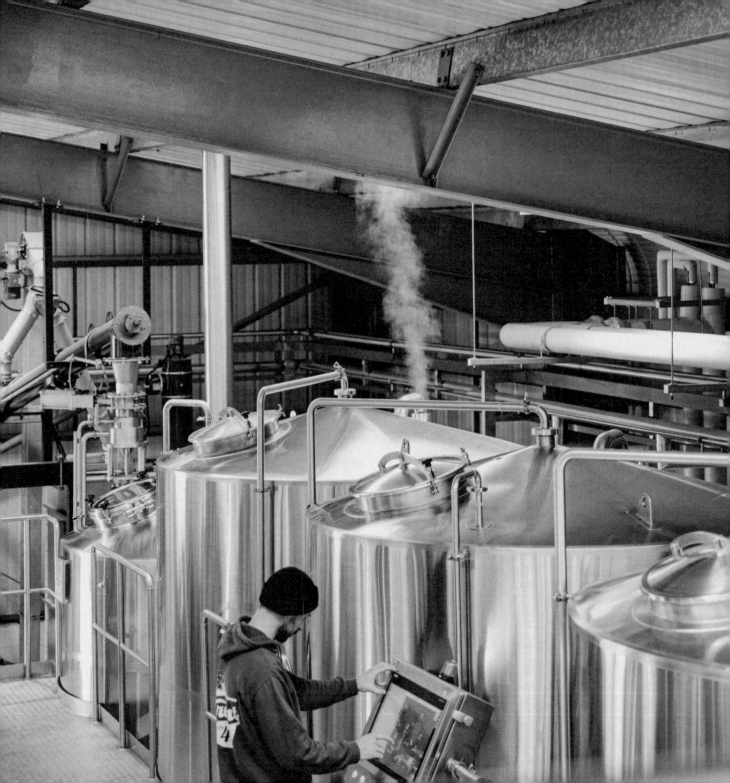

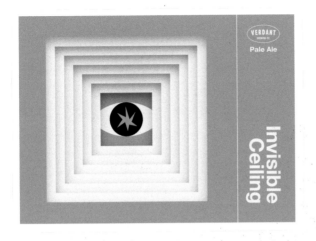

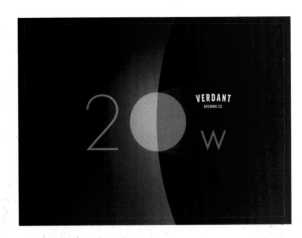

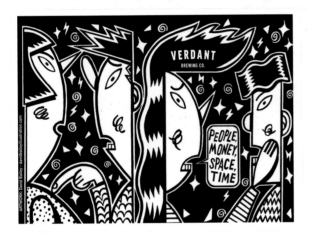

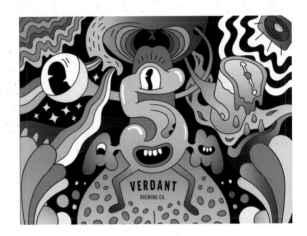

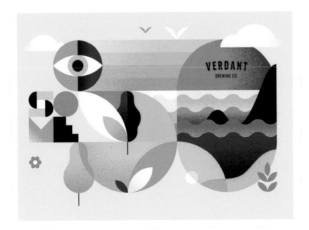

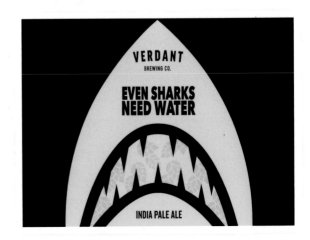

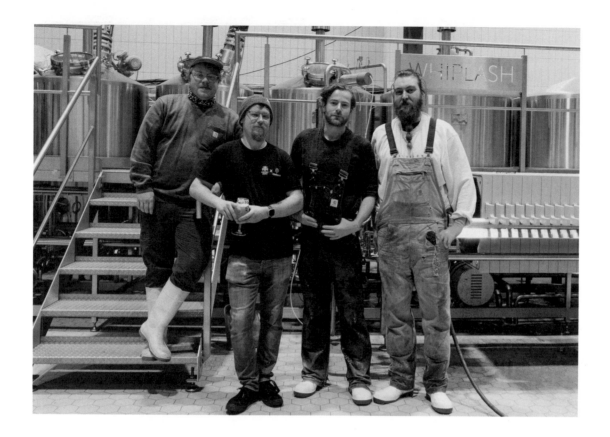

WHIPLASH

WHIPLASH BEER
DUBLIN, IRELAND

Founded in 2016, Whiplash started as a weekend project for Alex Lawes &
Alan Wolfe, both already working busy jobs in the beer industry. The idea
for Whiplash came about when they wanted to slow things down a little
and make some one-off beers on the side for fun. With increasing demand,
Whiplash commissioned their own custom designed brewery in Dublin and
have put out over 100 different beers, with styles ranging from modern double
IPAs and hazy pales to traditional dark lagers, stouts and porters. Each can
is adorned with collage artwork from Dublin-based artist Sophie Devere.

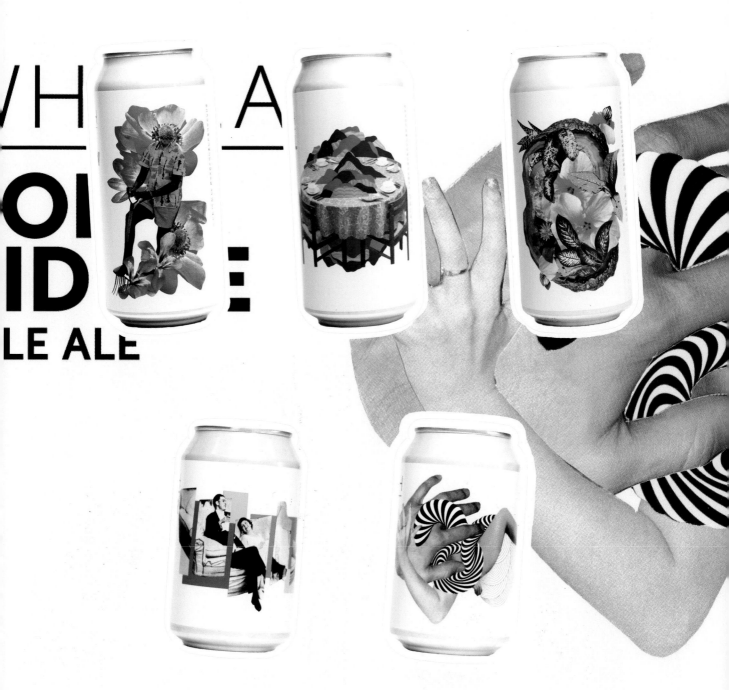

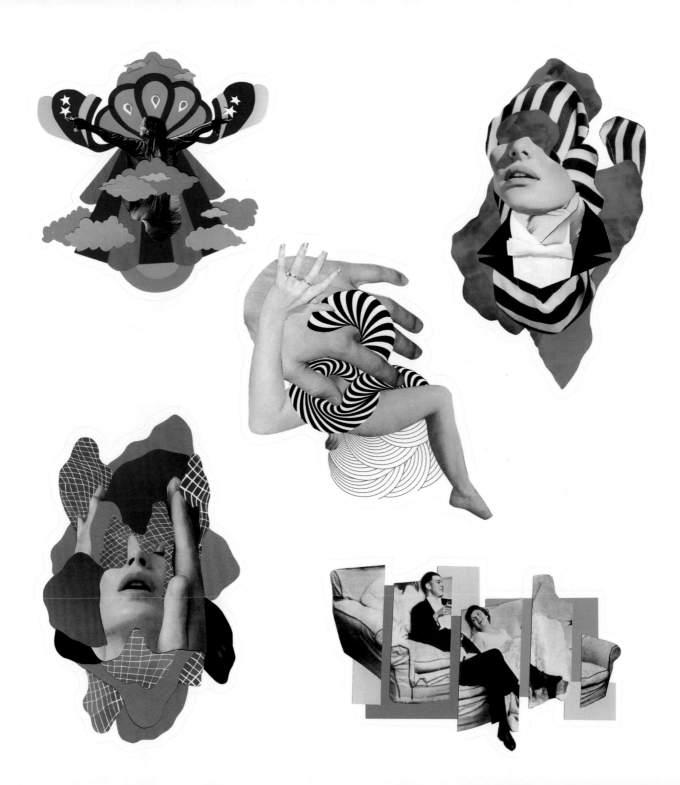

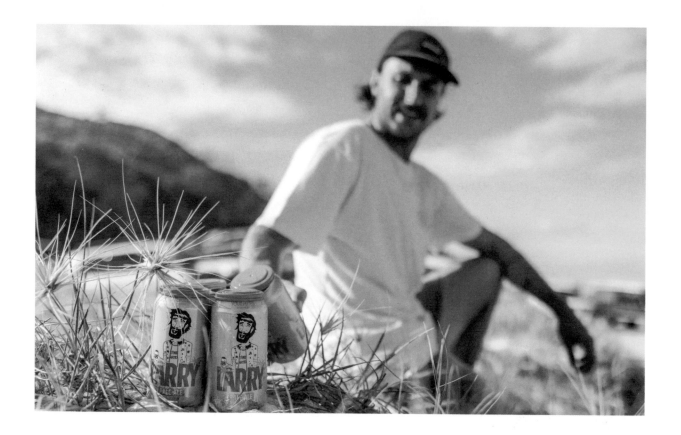

YOUR MATES BREWING CO.
WARANA, AUSTRALIA

Born on the Sunshine Coast in 2013, this story was crafted by a community of mates with a dream of living their passion and celebrating everything great about our Australian culture. It began with two mates, Hep and McGarry, sitting on a blue futon in their makeshift garage bar chewing the fat about life. Drinking craft beer was a new hobby of theirs, but after a while they struggled to find a beer brand they could connect with. "Maate, how bloody hard could it be!?" Nearly a decade later Your Mates are now one of the most popular craft breweries in Australia, with their flagship brew Larry recently voted no.3 in Australia in the GABS Hottest 100 2021.

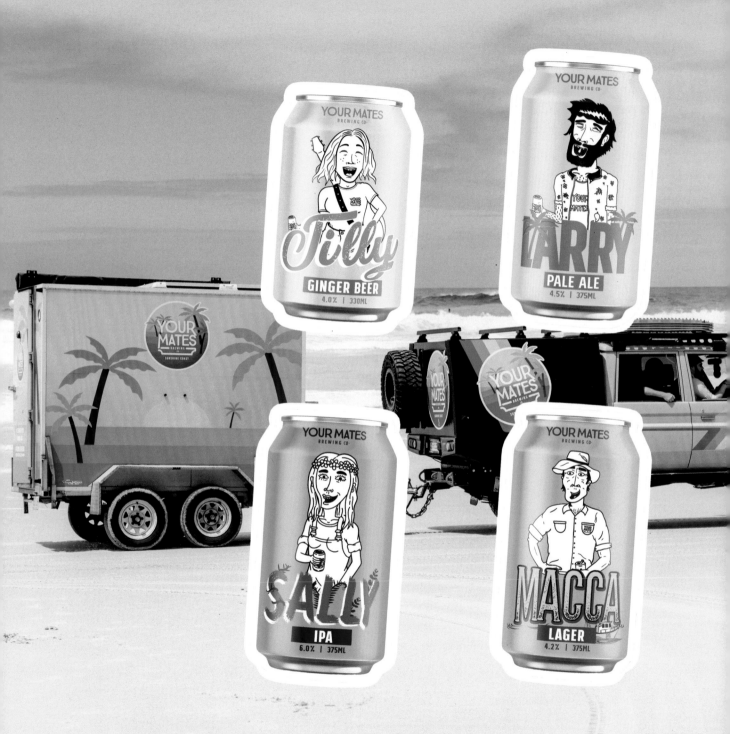

Index

Thank Yous

Steve Aston

Mark Hewitt

Matt Rudge aka Mr IXA

Felicity Awdry

Killian Radtke aka Don Grizz

Laurence King

Jo Lightfoot

Simon Sanada

Kasper Ledet

September Withers

Jamie Winder

Jordan Kostelac

Nick - The Happy Brewman

Rene Perez

Leah + Reza

Alec, Enzo and Luca

Claire & Em @ Turnaround